# 第三届中国油画年展作品集

SELECTED WORKS OF THE THIRD ANNUAL EXHIBITION OF CHINESE OIL PAINTING

第三届中国油画年展组织委员会编

岭南美术出版社出版

EDITED BY COMMTTEE OF THE THIRD ANNUAL EXHIBITION OF CHINESE OIL PAINTING

LINGNAN ART PUBLISHING HOUSE

第三届中国油画年展

吴冠中

The Third Annual Exhibition of Chinese Oil Painting

Wu Guan-zhon

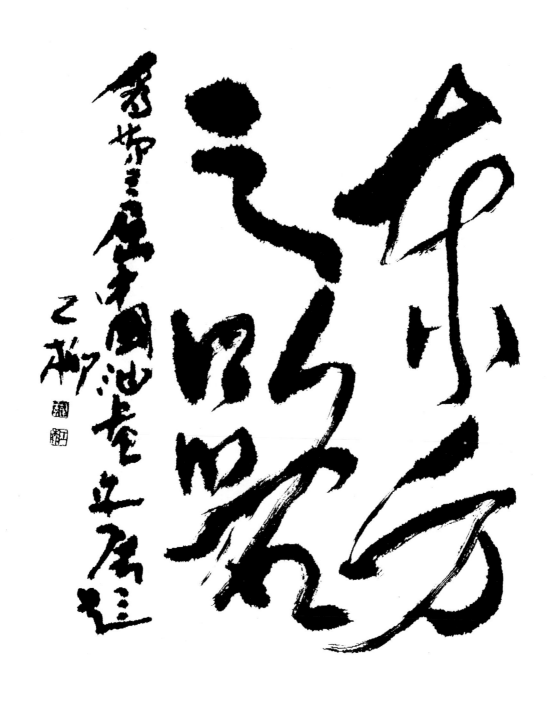

Oriental Art  Road Inscription for the Third Annual Exhibition
of Chinese Oil Painting

Luo Gong-liu

# 第三届中国油画年展（1995）

## 北京·中国美术馆

1995年12月27日－1996年1月7日

**策划**

杜文彬、刘国华、刘骁纯、何　冰

**组织机构**

主　　办：北京东方艺术厅

协　　办：《江苏画刊》编辑部

　　　　　《中国油画》编辑部

　　　　　北京莱曼实业总公司

　　　　　华瀚国际文化发展公司

后　　援：中华人民共和国文化部艺术局、

**组织委员会成员**（以姓氏笔划为序）

名誉主任：吴冠中、罗工柳

主　　任：杜文彬

副 主 任：刘国华、刘骁纯、何　冰、杜滋龄、程大利、曾晓田

艺术主持：刘骁纯

展览总监：何　冰

委　　员：水天中、王淑贤、皮道坚、江　心、孙为民、安远远、

　　　　　刘国华、刘骁纯、何　冰、张　胜、杜文彬、李建国、

　　　　　杜滋龄、金克弘、曾晓田、路海燕

宣传秘书：江　心

学术秘书：柴　宁

行政秘书：安远远 、唐　煜

形象策划：傅　沙

市场顾问：路海燕

法律顾问：刘　宏

办 公 室：王淑贤、冯　宇、江　南、李绍华、李桂娟、金克弘

**学术委员会成员**（以姓氏笔划为序）

主任委员：刘骁纯

副主任委员：水天中、皮道坚、孙为民

委　　员：王　林、王怀庆、水天中、韦尔申、尹吉男、皮道坚

　　　　　许　江、刘国华、刘骁纯、孙为民、阎振铎、何　冰

　　　　　张　胜、李建国、杜文彬、杨力舟、杨悦浦、邵大箴

　　　　　肖　峰、宋惠民、闻立鹏、贾方舟、彭　德、雷正民

# The Third Annual Exhibition of Chinese Oil Painting in 1995
Beijing.China National Art Gallery
December 27,1995----January 7,1996

## Planned by
Du Wen-bin  Liu Guo-hua   Liu Xiao-chun  He Bing

## Organizers
Presented by:  Beijing  Oriental Art Gallery

In association with:  <<Jiangsu Art Monthly>>Editoral Board

       <<Chinese Oil Painting>>Editoral Board

       Beijing Glamour Industry Company

       Hua Han International cultural Development Corp.

Supported by:  Arts Bureau of Ministry of Culture,P.R.C.

## Committee Members
Honorary Chairman:  Wu Guan-zhong Luo Gong-liu

Chairman:  Du Wen-bin

Vice-chairman:  Liu Guo-hua Liu Xiao-chun He Bing  Du Zi-ling

     Cheng Da-li Zeng Xiao-tian

Art Director:  Liu Xiao-chun

Exhibition Director:  He Bing

Members:  Shui Tian-zhong Wang Shu-xian Pi Dao-jian Jiang Xin

   Sun Wei-min  An Yuan-yuan Liu Guo-hua  Liu Xiao-chun

   He  Bing  Zhang Sheng  Du Wen-bin Li Jian-guo

   Du Zi-ling Jin Ke-hong Zeng Xiao-tian Lu Hai-yan

Publicity Secretary:  Jiang Xin

Academic Secretary:  Chai Ning

Administration Secretary:  An Yuan-yuan Tang Yu

Form Planner:  Fu Sha

Legal Advisor:  Liu Hong

Officers:  Wang Shu-xian Feng Yu Jiang Nan Li Shao-hua

   Li Gui-juan Jin Ke-hong

## Academic Committee Members
Member in chief:  Liu Xiao-chun

Member in vice-chief:  Shui Tian-zhong Pi Dao-jian Sun Wei-min

Members:  Wang Lin Wang Huai-qing Shui Tian-zhong

   Wei Er-shen Yin Ji-nan Pi Dao-jian Xu Jiang

   Liu Guo-hua Liu Xiao-chun Sun Wei-min Yan Zhen-duo

   He Bing Zhang Sheng Du Wen-bin Yang Li-zhou

   Yang Yue-pu Shao Da-zhen Xiao Feng Song Hui-min

   Wen Li-peng Jia Fang-zhou Peng De Lei Zheng-min

## 第三届中国油画年展获奖艺术家名单

金　奖：冷　军　杨成国　徐晓燕

银　奖：石　冲　申　玲　夏俊娜　忻东旺　阎　萍　邓箭今

铜　奖：宫立龙　刘丽萍　刘大明　杨国新　苏东平　洪　凌

　　　　刘国新　李延洲　郭　晋　郭润文　陈淑霞　杨国辛

佳作奖：徐　虹　唐　晖　吴维佳　莫鸿勋　于振立　胡朝阳

　　　　张国龙　秦秀杰　井士剑　顾黎明　贾鹃丽　陈　曦

　　　　袁晓舫　郭正善　徐安民　王清丽

---

## 《江苏画刊》 新人奖

《江苏画刊》在第三届中国油画年展征集作品中独立评奖

石　冲　《欣慰中的年轻人》

石　磊　《论感知》

赵能智　《梦游系列之四》

## Awarded Artists of the Third Annual Exhibition of Chinese Oil Painting

Gold  Award:　Leng Jun　Yang Cheng-guo　Xu Xiao-yan
Silver  Award:　Shi Chong　Shen Ling　Xia Jun-na
　　　　　　　Xin Dong-wang　Yan Ping　Deng Jian-jin
Bronze  Award:　Gong Li-long　Liu Li-ping　Liu Da-ming　Yang Guo-xin
　　　　　　　Su Dong-ping　Hong Ling　Liu Guo-xin　Li Yan-zhou
　　　　　　　Guo Jin　Guo an Xiao-fang　Guo Zheng-shan
　　　　　　　Xu An-min　Wang Qing-li

---

## New Painter Award of<< Jiang Su Art Monthly>>

Award Appraised Independent By <<Jiang Su Art Monthly>> from collecting works of the Third Annual
Exhibition of Chinese Oil Painting
Shi Chong　　　　Gratitied Young Man
Shi Lei　　　　　On Perception
Zhao Neng-zhi　　Sleepwalking Series No.4

# 第三届中国油画年展作品集目录

# Contents

# 可 喜 的 探 索

吴冠中

第三届中国油画年展突出"东方之路"的学术主题是一个很好的构想，这的确是中国当代油画所面临的重大课题。中国油画要自立于世，必须走出一条属于自己的"东方之路"，这是一个艰苦的过程，需要几代艺术家坚持不懈的努力。

油画是个外来的画种，它是20世纪西风东渐的产物。中国人画油画必须要有一个向西方学习的过程，这就要求艺术家要真正的吃透西方。同时，中国艺术家毕竟处在中国的文化环境中，要想形成自己的风格，也必须钻研中国的传统，真正的吃透东方，只有这样才能走出一条属于自己的成功的"东方之路"。这决不是一件简单的事。当年郎士宁在中国生活了几十年，想走出一条东方之路，但他并没有真正了解中国，只是简单的照搬了东方传统文化的图式，这条路是走不通的。现在有一些画家一味强调向西方学习，戴上西方的假面具，结果不伦不类，这条路更是条死路。通过这次年展可以看出，东方之路不止一条，它的容量很大，许多优秀的中青年艺术家都在各自的艺术状态中探索，这是一个非常可喜的现象。

第三届中国油画年展是中国油画闯出自己的路的重要过程，预祝展览获得成功！

# 学 术 操 作 与 商 业 利 益

杜文彬

　　东方艺术厅作为主办方投资第三届中国油画年展，购藏所有的参展作品是有商业因素的，但我并不认为商业利益与学术操作有矛盾，恰恰相反，商业上的成功是学术操作规范化和高品位的保障。

　　随着经济体制的转轨，艺术品进入市场成为不可阻挡的趋势。遗憾的是，中国艺术市场举步维艰，商业操作与学术很难结合起来，因此造成艺术品市场的趣味不高，有相当一部分艺术家只对海外市场抱有希望。我们举办这次年展，就是希望能够为国内的商业性艺术投资创造一种良好的学术环境，同时也给学术成果一次整体展示的机会。

　　长期以来，在我国艺术市场中，缺乏具有较高品位和长远眼光的投资，更多的是牟取暴利的短期行为，结果把市场搞得乱七八糟。认真作画廊的人惨淡经营，很难具备必要的开发性和指导性投资所需的资金，而另一些投机分子毫无社会整体意识却大发其财，失去中介机制的中国艺术市场迫使画家不得不花很大的精力去为自己的作品找出路，这是一种极不正常的循环。

　　艺术要发展，就必需有人投资学术性的艺术，从商业角度讲，这种投资虽然回收周期长，但却具有更大的升值潜力，我相信这次对第三届油画年展的投资会有一个圆满的结果。希望更多有识之士能加入到高品位艺术投资的行列中来。艺术创作者们应该相信：良好的市场环境是艺术的朋友。

<div style="text-align:right">１９９５年１０月</div>

# 告 别 仪 式

何冰

 １９８７年以来，全国美展模式的油画大展，大约搞了七八次，以当时的社会背景来看，这些大展对推动中国油画发展都起到了重要的作用，其功不可没，但这一切毕竟都已成为历史。九十年代以来，国家转向市场经济，但在新旧体制交替时期，必然会出现诸多弊病，法制不够健全，以权谋私和贪污腐败等局部现象十分突出，这些不可避免地给初级阶段的市场经济和艺术创作带来消极的一面，如德道观念和民族自豪感在某种程度上削弱，拜金主义有所抬头，这些现象只能在改革开放中去逐渐克服。在这样的社会状态下搞全国性美术大展，如果仍按计划经济的模式来办，由国家出钱，全国各级美协当作宣传任务，聘请专家层层评选，已远远不能适应当前的社会形势。中国目前美术市场非常混乱，导致部分美术创作沦落为西方中心主义和东南亚市民口味的原料市场和生产基地，有的艺术家随波逐流，把创作变为制作，追逐功利而不是追求崇高的艺术精神。被海外把持的中国艺术市场，居然演出了一幅平庸的油画炒出八百万，一幅无笔无墨的墨竹捧到一千五百万的闹剧。在我们把类似的行活在东南亚爆炒的时候，是否也把尊严、理想和精神一起出卖了呢？更可悲的是，极为少数的艺术精英也被海外画商围追堵截，甚至成为其挣钱的机器，这真是我们历史和文化上的双重悲哀！从这样的美术市场反观美术创作，从美术创作反观美术教育，问题的确不少。从近几年的全国油画大展来看，其优秀作品几乎全部流向海外，这种现象不得不引起我们的深思，经济基础决定上层建筑，这是一条法则！如果艺术作品的销售出路只限于海外的话，那么，我们的艺术创作不受人家的影响和控制是不可能的！这仅仅是问题的一个方面。

 另外，全国美展的展览和评选模式同样不能再适应当前艺术思想和创作的形势。由于经济结构的变化，对外文化交流和考察极为普遍，美术界思想之活跃，冲出传统欲望之强烈，是我们始料不及的。然而美术界全国大展的评选观念，评选方式，评选结构都是十年一贯制，这怎么能行得通呢！人的思想不可能一成不变，现在谁也不再把艺术看成是政治和宣传的工具，来自各权威机构的十几位乃至二十几位中老年专家组成的评委各有主张，势必会产生尖锐的思想冲突，去年一次全国大展评选班子的矛盾恰恰揭示了这个问题。

 第三届中国油画年展力图在学术和展览的操作上有所改进，经过各方面慎重的讨论，决定请批评家主持学术操作，期望评出有鲜明时代个性的展览。由企业对展览投资，购藏全部作品，推动国内艺术市场。但这仅是一种美好的理想，在实际操作中，我们发现，还不可能跳出当前社会现实、经济现实。市场操作采取的公开购藏全部参展作品的方式与当前大多数画家由自己把作品卖到海外的作法差距很大，扑朔迷离的美术市场，短时期内不可能完全理顺，这一步是不是迈大了，值得研究。

至于学术和展览操作，通过实践来看，虽然力争有所推进，但依然未能从根本上跳出全国美展模式的窠臼。虽然评选出来的作品学术水准均属上乘，但也有相当优秀的作品落选和不能得到应有的奖次，批评失去了应有的力度和敏锐，这也是预料中的遗憾。

　　尽管如此，第三届中国油画年展采取购藏全部作品，为建立中国油画市场作出的努力还是突出的，在作品质量和学术操作方面也还是取得了很大的成功。但是在迈向二十一世纪的关健时刻，我想，把第三届中国油画年展看成一个历史时期在展览模式上的告别仪式，或许会对我们在转向坦途的艰难过程中有所启示。

<div align="right">

１９９５年１１月２６日

于　广　州

</div>

# 国 际 规 则 与 东 方 之 路

刘骁纯

在我的观念中，强调"东方之路"并不意味着否认"国际规则"，强调"国际规则"也并不意味着否认"东方之路"。

一

所谓"国际规则"，即欧美现代、后现代艺术所开创的属于"通律"的某些观念和形态。这种"通律"在油画这个特定的领域中至少有以下几个方面：

一、高度强调艺术家的自主性，即强调个体的独立性和创造性。这不仅限于个人风格，更重要的是艺术家对人生与艺术独特的理解和开创性，以及由此产生的对现成规则的挑战性。当然，这种挑战有高层推进和流寇造反、优质与劣质之分，这是另一个问题。

二、高度强调造型的自主性。这意味着无论是叙事性（如历史画、人物故事画、象征性的荒诞故事画等）还是非叙事性（如风俗、风景、静物、动物画、抽象画等），均不再以叙事为基本观念，叙事降格为精神表达的辅助手段，甚至完全受到排斥（如在非叙事性的绘画中），而造型自身不仅成为直接表达精神的手段，而且成为精神表达的主要语言。一个艺术家如果不能创造自己的造型语言，不善于使用造型语言表达观念，在造型的层面上精神亏空和语言苍白，无论选择多么重大的故事都不会取得艺术上的成功。反之，即使是画的一草一木，也可能为中国油画的发展开启思路。

三、高度强调光、色、点、线、面、体、画面构成的自主性。这意味着，无论是具象还是抽象绘画，均不以再现为基本观念，再现降格为精神表达的辅助手段甚至完全受到排斥，而古典意义上的形式因素，不仅成为直接表达精神的手段，甚至成为精神表达的主要语言。一个艺术家如果不能创造自己的光、色、点、线、面、体、布局上的结构语言，不善于利用结构语言表达观念，在结构语言的层面上精神亏空和语言苍白，无论其再现能力多么强都不会取得艺术上的较大成功。反之，即使画的几根线条，也可能为中国油画的发展开启思路。

四、高度强调材料的自主性。这意味着不论是纯粹油画还是融入各种综合材料的边缘油画，媒介物质均不再是手段的手段，刀、笔、油、彩、木、纸、腊、粉的自身性格转化为观念和精神表达的重要手段，甚至基本手段，人与材料打交道的堆、刮、挑、抹、钉、挤、压、粘的过程转化为观念和精神表达的过程，过程即创造、即表达、即精神、即语言。一个艺术家如果仅仅把过程视为对设计蓝图的完成任务的机械过程，如果不善于在刀、笔、油、彩的堆、刮、挑、抹中表达观念和精神，在笔触与画肌的层面上精神亏空和语言苍白，那么即使成功也是有重大缺憾的。反之，即使看似随意的几下粘、刮、堆、刷，也可能为中国油画的发展开启思路。

五、基于以上诸点，象征性、表现性、抽象性、边缘性油画的发展，学院性与前卫性的对抗，以及艺术多元化的趋势，均不可阻挡。

15

<center>二</center>

所谓"东方之路"，即中国油画在向现代观念和现代形态推进，以及吸收后现代因素的过程中，必有与欧美不尽相同的方式，并由此产生异于欧美的创作成果。

如果说２０世纪是中国油画创造性地向欧洲学习的世纪，那么２１世纪将是中国油画以更独立的东方精神和中国气派自强于世的世纪。我们面对着世纪之交的历史性转折。

"东方之路"是个过程，是面对中西古今的冲撞，中国艺术家群的灵魂遭际和生命展开的过程，是真实而又真诚的创生过程，它的本质是创造，特别是天才们的创造。

"东方之路"过去的轨迹比较清楚，未来的可能却难以预测，正如一个艺术家生命展开的未来可能难以预测一样。创造总是意外的。

中国油画所走的路，既不是西方文化中心主义设计的路，也不是简单搬用民族文化图式就能告成的路，而这两端恰恰经常合流－－中国文化越是热烈地敲击自己文化的"威风锣鼓"，西方人便越是以猎奇土著文化的俯瞰视角为之热烈鼓掌。而真实面对中国与世界的存在的灵魂，则在这种旅游文化热中孤独地挣扎。

一个概念，如果它的外延越大则内涵越小。"东方之路"像"民族化"之类的说法一样，因其宽泛而缺少具体的实际意义。如果把这类说法理解得过于具体和实际，其结果不是变成束缚想象力的桎梏，便是导致出庸俗肤浅的作品。"东方之路"的说法，只有在特殊的针对性中才能显出较实际的意义。例如：在１９９３年的威尼斯艺术双年展上，中国展馆的主题词就是"东方之路"。在那个展览上，主要展出的是政治波普和顽世现实主义，那其实是西方人眼中的东方之路，是窄化了的东方之路。第三届中国油画年展借用了那个主题词，意在转换它的语境，因此有一定的针对性。我想，中国油画创生过程的内在脉搏，只有中国人自己才能更准确地把握。

将接受现代、后现代艺术某些观念和形态的作品一概视为"西方化"，显然是认识上的错位，"东方之路"的主要所指恰恰是创造东方精神和中国气派的现代文明。在油画这个特定领域中，主要是指现代形态、现代风格的中国油画，以及吸收某些后现代因素的中国油画。

在前辈油画家踏出的路上，一批站在高起点上的中、青年艺术家正在成为中国现代文明新一代的开拓者和创造者，他们使"东方之路"充满了风险和困惑，又使"东立之路"充满了魅力和希冀。

<div align="right">１９９５・１０・</div>

9

陈淑霞　《粉红色的花》　一届年展银奖作品
**Chen Shu-xia** PINK FLOWERS

吴维佳　《信天游》　一届年展作品
**Wu Wei-jia** ROAMING

# 东 方 之 路

## ——过去时态与未来指向

皮道坚

  与前两届油画年展最大的不同是，本届油画年展邀请了一定数量，当然也是具有不尽相同的学术观点和批评眼光的批评家参与策划和评审。因此尽管它的运作仍采用了一些商业性手段，但它的学术性取向却是相当明显的。由批评家们确定的学术主题——东方之路，一开始就表明展览所关注的是世纪之交中国油画的当下创作态势，以及这个态势中所包容的"东方之路"的过去、现在和它的未来指向。而展览的主导思想则无疑是力图在中国当代艺术中强调一种独立的东方精神和一种面向新世纪的开放的文化态度。

  应该说，从由批评家、画家、收藏家、活动家组成的学术委员会按照共同认定的规则，经过三个阶段、长达半年之久，几乎未曾间断的争议与反复评审后所确定的１１４件参展作品来看，上述学术主题还是得到了较为充分的体现。尤其是中国油画经过一个多世纪吸收西方文化的艰难历程，在本阶段所取得的学术成果，在这个展览中有着较为全面、生动的反映。

  本世纪二、三十年代以来，在中国社会的现代化转型，中西文化冲突、激荡的过程中，油画坛一直是一个文化视野最为开阔，艺术感觉最为敏锐，创造活力最为充沛的领域。从发端于二十年代关于人体绘画的新、旧观念激烈交锋，到七、八十年代关于艺术形式问题，现实主义与现代主义问题，艺术语言问题的一系列论争，中国现代艺术的每一次重大推进都与中国油画的发展密切相关。几乎艺术领域的每一次革故鼎新，都有油画家们和关注油画创作的理论家们担当先锋和中坚的力量。正是上述一系列论争以及与之相关的油画创作实践，开拓了一条中国油画的东方之路。而以"东方之路"为学术主题的本届年展，也正是通过当下油画创作中各种风格、流派，各种创作观念和手法的代表作品呈现了这条东方之路上的历史风云。

  然而，批评家理应着重关注的是油画创作的当下态势，以及呈现于其中的新视野、新感觉和新的语言结构。应该说在本届年展的一些最后参展作品与一些未曾入选的作品中，这些均有显著表现。无论是油画语言结构的开放性，还是传统油画范畴的模糊化，都在向我们的感觉尖锐挑战，令人无法回避。必须看到这是艺术家们在摆脱旧的油画语言模式和狭隘的民族主义立场之后，所获得的一种对于当代世界文化的积极参与精神的显现。在克服了由对西方中心主义的拒斥而导致的病态心理行为之后，一些优秀的艺术家得以坦然自如地用一种现代的东方眼光和经验，来观察和处理当代问题。石冲的《欣慰中的年轻人》所表达那种令人心灵震颤的与人类自身面目赤裸裸的直接遭遇，石磊的《论感知》所表达的对人类当下生存状态的敏锐把握，都在相当程度上介入了当前的世界艺术潮流，并且都在艺术水准上令世界刮目相看。更年轻一些的艺术家，如唐晖等人更以一种以往艺术家所不曾有过的轻松态度出现在画坛。无论是石冲等将行为、装置、现成材料向架上绘画的移置，还是唐晖对虚幻图像的组接，都是在试图以真诚的内心自我和艺术直觉为现实的指南，也许他们在其作品中所注入的情感比他们的作品所包含的思想，对我们有更加重要的意义。

  正如任何已经发生的事情都会或多或少给我们留下永远无法弥补的遗憾一样，本届油画年展的评选也有让人久久不能释怀之处。因为不仅有一些具有上述品质的优秀作品被我们排斥在展厅之外，即使是在对参展

作品的评奖定位中，我们也没有表现出对当前油画创作态势应有的积极回应。从严格的学术意义上说本届年展的评审和评奖着眼点多只在"东方之路"的过去时态，而对它的未来指向却缺乏应有的敏感。尽管组委会作了相当大的努力，使比以往更多的批评家参与到年展的评审工作中来，然而占评委总数三分之一的比重，以及批评自身的萎缩，仍使批评家对年展所起的作用显得苍白无力。

1995年10月9日
于北京国务院二招

姚永 《仙人掌》 一届年展作品
**Yao Yon** CACTUS

姚永 《鸡冠花》 二届年展作品
**Yao Yong** COCKSCOMB

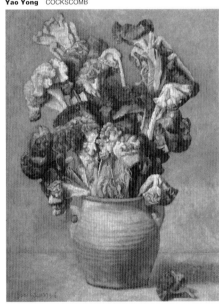

李天元 《冶子》 一届年展金奖作品
**Li Tian-yuan** THE SEDUCTRESS

# 画 家：要 有 理 想 和 追 求

邵大箴

　　中国油画，不论是写实的，还是其他形式的，都存在着继续提高技巧的问题，技巧不成熟对中国油画家来说是普遍存在的缺陷。但当前中国油画发展中最令人忧虑的不是技巧问题，而是精神层面上的不足，也就是这两三年来人们常常说的缺乏精神性的问题。

　　艺术作品是表达思想和感情的，思想的容量大小是决定作品成败得失的关键。表达思想感情要借助于媒介和手段，因此研究媒介和手段，研究艺术技巧是摆在艺术家面前的永久课题。但是媒介、手段和表现技巧，只有在作品思想感情充实时才能发挥相应的作用，倘若作者缺乏有深度的思想、缺乏诚挚的感情，媒介、手段和表现技巧便失去了意义。在这种情况下，矫揉造作之风便盛行，玩媒介、玩技巧便盛行。

　　西方现代主义的艺术已经被我国的艺术家逐渐理解认识。从整体上讲，现代主义流派有许许多多的不足，有许许多多值得我们汲取的教训，但它包含的一个可贵的品质我们却可以借鉴，那就是它追求的精神性，它的批判锋芒，它关注现实的鲜明态度。当然它的过激性和某些虚无主义的观念，我们应该避免和舍弃。近两年来，我们展出了蒋兆和、徐悲鸿、王式廓等人的作品，他们作品的可贵之处就在于有强烈的精神追求。这精神性来自于这些作家对社会和现实的关注，对人民大众事业的满腔热情。这是"五四"以来我国现实主义艺术的重要特点。我们要继承和发扬这一传统，不要只看到那个时期艺术中的不足，而对其中最宝贵的东西加以忽视 。

　　我看当前有些画家的作品中缺少一种生气，缺少一种力量，大概有些人的生活太安逸了，囿于安乐的小环境，而对现实和社会疏远。这些人没有生活体验，没有真情实感，没有强烈的表现欲望，便想着招儿来玩弄技巧，有时美其名曰是"深化语言研究"。由于他们在画中寄托的感情苍白无力，观众对他们的画也就漠然处之。

　　画家要有个性，没有个性的画家画不出有特色的画来。但是画家在发挥个性的同时，要注意和社会大众的交流，要注意自觉地受艺术规律的约束。随心所欲地发挥个性，看来相当潇洒自由，但往往如五光十色的肥皂泡，闪光一时便很快化为乌有。

　　看来，提高作者的修养和素质，是我国画界的当务之急。

石磊 《山地系列之一》 一届年展作品
**Shi Lei** LANDSCAPE SERIES,No.1

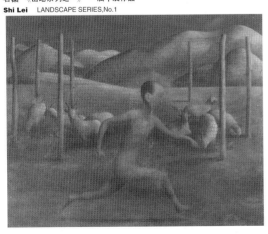

石磊 《家事详解》 二届年展作品
**Shi Lei** DETAILED INTERPRETATION OF HOME AFFAIRS

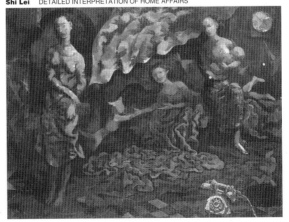

# 从 三 届 年 展 看 中 国 油 画

贾方舟

　　中国油画年展从第一届（１９９１年）到第三届已经跨越了五个年度。这种定期连续运作的展览方式，不仅可以呈现艺术在某一阶段发展演化的清晰脉胳，而且可以显示一个连续参展的画家的成长与变化过程。而通过各种奖项的方式不断推出新人，更成为此类展览持续操作的价值所在。

　　若将三届年展加以粗略比较，我们不难看到一些重心的偏移与变化：从古典风转向充满生命激情的表现；从单纯地显示写实技巧转向与观念的结合；从风情描绘转向对当下现实的思考，以及从具象转向抽象，从油画语言转向材料语言等。而这些变化与倾向，也是构成本届年展的一些显著特点。从这里不难看出艺术自身的演进，既是一个不断向新的表现领域推进的过程也是一个不断自我调整的过程。因此，当一种新的取向出现时，就不仅预示着向新领域的跨越，也预示着对既有倾向的矫正。中国油画在过去一些年中表现出的那种取悦于商业需要的媚俗倾向，在这届年展中得到进一步的纠正。尽管历届年展都不回避后期的商业操作，然而，学术品位却始终是它追求的目标。历届年展的获奖作品，即可视为它所倡导的学术范例。在大倡"主旋律"的背景下，王怀庆以"一把椅子"（指《大明风度》）首获金获，即以最明朗的方式显示了"年展"所确立的学术方位。如果我们能连续看看历届一些重要的获奖作品，这一印象会更加明确。王怀庆的《大明风度》，李天元的《治子》、周向林的《１９６９年１１月１２日－－－开封》、石冲的《被晒干的鱼》、《行走的人》、陈淑霞的《粉红色的花》、阎萍的《母与子》、陈文骥的《红色的领巾》、胡建成的《折射》等，都是这一时期具有代表性的作品。中国油画如何切入传统，如何表现当代人的心态，又如何在人性这一主题中作出富有个性的拓展，都可以在这些作品中找到范例。当然，也不能不看到，由于官方参予这类展览活动，还难以将这一时期最活跃的一些艺术家纳入进来，将他们的实验性艺术吸引到展览中来，这是无论从政治的考虑或商业的考虑都无法突破的局限，即使批评家主持的本届展览，在这方面也只能做出十分有限的推进。一些敏感的画题必须回避，一些越出边界的形式与表现手法也暂不能考虑。然而，年展的优势并不在它所具有的思想锐气和前卫立场，而在于它对中国油画的当代发展的学术推进，在于以最高奖项的方式不断推出新人。

　　若从这一角度看，年展活动在中国当代油画艺术的发展中所具有的作用和意义是不容忽视的。许多青年画家正是借助年展活动的连续举办，才得以展示自己的艺术进展。不少在第一、二届年展中参展的画家，在本届年展中获奖，甚至获了最高奖，如徐晓燕、杨成国、忻东旺、宫立龙、苏东平、袁晓舫、顾黎明、吴维佳等。有些过去参展的画家则在本届展览中获得"特邀画家"的荣誉，如蔡锦等。还有一些连续获奖的画家，如石冲、冷军、阎萍、洪凌等。而在由年展推举出来的画家中，石冲是最具代表性的一位。

　　三届年展，石冲均有作品参加，首届年展获银奖《被晒干的鱼》，第二届年展获金奖《行走的人》，本届又获银奖《欣慰中的年轻人》。几年来，石冲在艺术上始终处于进取状态，而且始终将自己的艺术方位

确定在对生命的关注与对人的生存状态的把握。在首届年展中，他以无懈可击的技巧将一条被晒干的鱼作为生命的物质痕迹作了化石般的描绘，待到第二届年展中，他便以《行走的人》独领风骚，在人性这一母题上展开了他纯属个人方式的解读。本届年展，他展出的作品为《欣慰中的年轻人》，在更深的层面上展开了对人的生存状态与生存环境的自我反省。赤裸的人赤裸裸地展示着一只赤裸的鹌鹑，那自我质问的红红的眼神令人心灵颤栗。石冲所表现的这种自我反省状态使我产生一种深深的罪恶感，遗憾的是人类每天都在重复着这种值得反省的行为却从不自省。在石冲的作品中，技艺的高度与思想的深度同步而行。

与石冲双峰并峙的另一位画家是冷军。他们同在湖北，又差不多是同时崛起。在三届年展中，他展出的作品分别是《骨头、木头》、《网－－关于网的设计》和《世纪风景》。第一件作品只有单纯的技法意义，非常写实的技巧令人惊叹，此外再难向观者提示更多的东西。若联系他同期的另外两件作品看，《马灯的故事》虽然引发了一个情节的联想，从而被赋予了一个革命的主题，然而并没有摆脱作品的肤浅。而在《被包捆的亚麻布》中，始有了某种隐喻色彩和可沉思的东西。待到《网－－关于网的设计》，则表现出写实与观念融合这一新的趋向，在极端的写实功夫中渗透出智慧之光。而从《文物－－新产品的设计》到本届参展的《世纪风景》，更将这一观念的因素放大，显示出更深一层的精神取向。在《世纪风景》中，画家用象征着工业文明的废弃物组接铆焊成一幅极具视觉强度的世界地图，同样表现了画家对人类行为及文明进程的某种担忧与思考。与石冲、冷军所代表的极端写实画风形成强烈对照的是一大批具有表现主义倾向的作品。申玲、阎萍、夏俊娜、邓箭今、苏东平、王玉平、刘大明、于振立、张国龙、莫鸿勋等，他们或具象或抽象，但都以充满激情的画笔表现着心灵的悸动与生命的亢奋。而在这两种倾向之间，一位独具风格的新秀徐晓燕脱颖而出。在前不久举办的《中华女画家邀请展》中，她的一组《秋季风景》即以出色的表现引人触目，而在本届年展中，他的作品更是得到最高首肯。在上届年展中，她画的也是白菜地，但表现一般，尚未引起人们注意，两相比较，进步是惊人的。她的《秋季风景》，写实中蕴涵着浓郁的表现色彩，如果说冷军的方法是消灭笔触，直呈物象，那么，笔触在她的作品中却有举足轻重的作用。她把包容万物的大地给予人类的无私馈赠描绘得既质朴深厚，又美丽动人。她的作品甚至让人感到最富魅力的表现对象倒是最平常的对

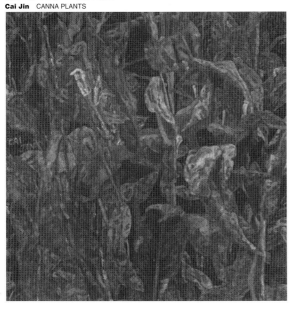

蔡锦 《美人蕉》 一届年展作品
Cai Jin CANNA PLANTS

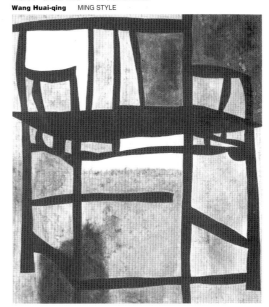

王怀庆 《大明风度》 一届年展金奖作品
Wang Huai-qing MING STYLE

象。而她的功力也正在于她能把这种平平常常的自然景物描绘得这般富有生命情调，这般充满活力，这般深厚、博大、炽烈而如母亲的胸怀。她的笔触的表现力极具油画风采，而对天空的处理更显得身手不凡。可以说，她是继上两届年展之后推出的又一位值得关注的新人。

与上两届年展相比，这届年展的另一个显著特点是对"边缘油画"的进一步宽容，材料语言的介入，改变或扩大了油画的物质成分与语言形态。刘刚的金属、徐虹的石子与宣纸、段江华的布与木板、蔡锦以席梦思床垫代布，以及刘丽萍的"画中有画"（以一个局部构成全局的"画眼"）与莫鸿勋的"画外求画"（通过画框强调作品力度）等等，均在运用油画语言的同时探索材料语言的表现力。这些画家的试验，一方面丰富了油画的表现力，同时也有可能走出油画，在一个更大的空间展示自己的创造才能。

由此不难看出，中国油画年展已成为青年画家大显身手的重要领域。组织者若能在举步维艰中将它持续下去，必将功德无量。

1995年10月10日

于北京国招331

5

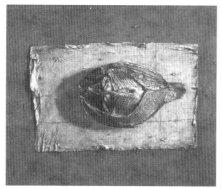

石冲　《被晒干的鱼》一届年展银奖作品
**Shi Chong**　DRIED FISH

石冲　《行走的人》二届年展金奖作品
**Shi Chong**　A WALKING MAN

闫萍　《母与子》二届年展银奖作品
**Yan Ping**　MOTHER AND CHILD

# 中国油画的都市化倾向与都市文化中的人格问题

王林

如果说原始艺术是人类学的，古典艺术是社会学的，现代艺术是形态学的，那么，当代艺术显然是文化学的。

当代文化的转型可以从种种方面加以分析，如文化传统的交叉与互动、文化阶层的分化与融合、文化地缘的差别与联系等等，但对八九后的中国油画来说，最突出的变化则是都市化倾向的凸现。

就油画范围而言，中国美术八十年代的成就是乡土绘画，以其对社会现实和历史问题的自觉反省吹响了批判精神的号角。新潮美术作为反传统的文化运动，通过对个体意识的提升开始表现都市中人的生态与心态，但尚未全面切入都市生活和真正触及都市文化问题。八九年以后，一大批青年画家放弃对社会重负和文化理想的追求，承接新潮美术的个体意识而走向个人化、生活化和具体化，以其对个人真实生活及生活环境的特殊关照转向都市文化形态。这种转型和世界文化走向特别是中国自九十年代以来的文化走向具有一致性。当代社会由于行政、技术、人口特别是信息、媒介、消费向都市高度集中，都市已成为各种文化意识、文化权利、文化潮流的中心，当代文化即是都市以及都市向乡村扩散的文化，"农村包围城市"的可能性已经成为历史。官僚技术化和资讯媒介化使都市中人面临着新的生存问题、精神问题和文化问题。八九年以后，由于中国社会的继续开放和公共传媒的广泛普及，我们已被置入信息泛滥、消费主义、流行文化铺天盖地和知识精英边缘化的世界潮流之中。中国油画的都市化倾向正是在这种背景下产生的。由于中国都市及其文化的膨胀基于特殊机遇和经济奇迹，它的迅猛突发与夸张畸变使中国艺术家更为深刻地感受到都市文化的魅力与病态，因而有可能以其个别、强烈、深入的精神反应同步地为世界当代艺术作出自己的贡献。事实上，我们的艺术家在国际大展中已经开始改变冷战残余和人权例证的形象。相信随着都市化倾向的深入和海内外对等交流的增多，中国艺术家将会作为当今国际艺术活动中的重要力量登上历史舞台。

问题不在于我们怎样从题材上呈现了都市生活以及都市中人的生存状态，而在于我们如何在创作中表现感受的独特、心理的敏感和智慧的超前，也就是说我们如何以批判性的眼光和反省式的心态去看待和体悟今天的文化事实，从个体精神的独立、丰富和不断发展深化的需要出发，去呈现生命需求与文化现状的矛盾，超越既成事实和潜伏于既成事实之中的意识形态，从而推动文化朝着充实人而不是异化人的方向发展。以这种观点来看八九年后的都市绘画，我们应该警惕随波逐流的机会主义和消费娱乐的玩世心态。以玩笑化解严肃，如果是针对理想主义，有可能是对政治虚伪的嘲弄，也有可能是对精神真实的背叛。基于此，我并不一般地否定玩世的都市化倾向（其中不少批判性和精神性很强的作品），只是对以玩世自娱、自逞、自鸣得意的作品保持戒心。并且，玩世如果针对的只是实际生活中已失去价值的过时的政治理想，那它在精神上就没有提供什么新的东西，反而掩盖了在既成的日常生活之中潜伏的文化惯性和意识形态。而它们要取消的正是精神要求独立、丰富和发展的权利。这是一种更深刻的人权。流行文化即是以自动的群体认同而成为"微笑的法西斯"。如果我们在文化既成事实之中放弃人格理想和人格力量，我们不过是向着法西斯微笑的"同去同去"的俘虏。从另一方面讲不管达达主义和波普艺术怎样从现成世界和生活世界两方面拓开了艺术资源，艺术作

为精神的表征是既不可能被完全物质化也不可能被完全日常化的。在经历了现代主义对艺术本体的充分发掘之后，我们必须把艺术重新放回人的位置。艺术的问题就是人的问题，在今天也就是都市的问题。

在这本画册中，读者即可看到不少关注都市文化问题的作品，体会到艺术家对都市人生存状态的敏感、惊觉、省悟和批判。仅以获奖作品为例，即有石冲《欣慰中的年轻人》、申玲《午后懒洋洋的小女人》、邓箭今《来访者》、郭晋《飘过的上帝》、杨国辛《我们需要什么》等一批优秀之作，这些作品改变了前一段都市油画中那种竞赛嘻皮笑脸、抬举玩世不恭的状态，给人以深刻的印象。如果再加上那些未参加展览但在都市绘画中成就斐然的画家（如尚扬、张晓刚、刘炜、刘大鸿等），九十年代的中国美术界完全可以期待一种新的独立的当代的艺术成就。当然，油画只是其中的一种媒介。

<div align="right">１９９５年１０月９日于北京国务院二</div>

招

冷军　《骨头・木头》一届年展作品
**Leng Jun**　RONE AND WOOD

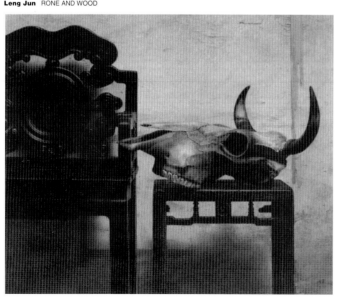

冷军　《网－关于网的设计》二届年展银奖作品
**Leng Jun**　NET--A DESIGN ABOUT NET

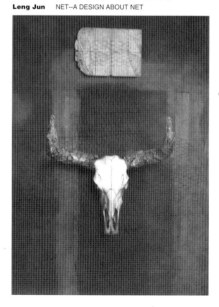

# 金 奖 辨

彭德

　　众多评委参评的美展比个人主持的展览对美术创作往往具有更大的伤害性。个人的责任感很容易在随大流的氛围中或情绪化的争论中丧失。七嘴八舌的即席评议常常变成一个不断挑剔拔尖作品的过程。当石冲作品在前几轮投票中与冷军作品均以相同票数高居榜首时，人们始终找不到一件能同这两幅画抗衡的作品，而石冲在最后一轮名落孙山，就是金奖评定中一个非常典型的现象。

　　石冲属于在国内功成名就的艺术家，他的发展脉络有着内在的逻辑性。他在装置艺术架上化中开风气之先，并在中国画坛很快形成一个具有声势的新流派。石冲把行为艺术架上化的今天，他更有理由成为被嘉奖的人物。金奖的评定不应该仅仅只是就画论画。在争论不休的情况下，它还应该考虑到作品的主人，即作者的实力、资历和潜力。

　　全国性美展评奖的流行模式，使得我们总是试图在预先设定的 3 件金奖作品中体现艺术形式甚至艺术题材上多元或多样化的面貌，尽管这种面貌已经体现在整个展览之中。金奖作品不可能承担这个艺术政策上的重任。写实、象征、表现，在三件金奖作品中形成鼎立之势，貌似公允，其实是削足适履。倘若只设一个金奖，是不是只有让亚威农少女长一张安格尔的姑娘面孔并在基弗尔的原野上遛达才有希望坐上第一把交椅？

　　体现艺术政策使作品的艺术成就在评奖中退到次要地位。《戏剧·三国》和《秋季风景》固然很不错，但欠缺获得金牌的充足理由。《戏剧·三国》是一件富有智慧的作品。它以调侃的构思揭示出一味复古的东方之路的荒谬性，但画面处理尚未达到炉火纯青的境界。《秋季风景》在画面处理上非常松动自由而又结实有力，显示着作者的才气，但它更多地只能满足学院艺术的趣味要求。两位新人能否成大器，还需要进一步的检验，将他们放在合适的奖位更有利于他们自警和自强。勉强地在展览中提携新人是时下美展的通病，它只是绿林好汉劫富济贫的平均主义思想对艺术创造者的嘲弄。它抑制了发展有序的优秀艺术家，也使初出茅庐的青年画家过早地被悬置，从而致使中国美术界难以坚实地、自觉地造就进入国际画坛的人物。

　　石冲和冷军作品在画风上都属于写实，两者的差异却显而易见。一个是静物，一个是人物；一个是装置艺术的架上化，一个是行为艺术的架上化；一个具有经典性，一个具有开创性；一个揭示文明中的悖论－工业文明导致世界的衰败，一个揭示文明中的伪善。石冲作品中精到得无以复加的画法和对人的深刻剖析，给人以视觉和心灵上的双重刺激。那只被剥皮的鹌鹑自古以来就是安宁平和的象征，它和化妆的人体在粉饰和揭露的两极中形成精神的冲突和感觉的尴尬，使人无法平衡。然而我们这个由一个个饱经世态炎凉的评委组成的评审团，在面对石冲作品的关键时刻竟失去了评审力。

1995.10.9

25

# Gratifying Quest

By Wu Guan-zhong

The academic orientation "oriental art road", projected at the Third Annual Exhibition of Chinese oil painting is a fine conception and also an important mission that Chinese contemporary oil painters have faced. It will be an arduous process that several generations make their unremitting efforts to establish a statue in the international art world.

Oil painting as a medium of western art, began in China in the 20th century. In studying oil painting it's needed that this western art form be thoroughly digested and understood. Meanwhile, in developing individual identity it's also needed that traditional Chinese culture be studied intensively. In those years, Joseph Castiglione had lived in China for several years and devoted himself to finding the oriental art road, it's a pity that he has nothing but simply copy the pattern of oriental traditional culture. Similarly, some Chinese artists completely emphasize on overall westernization so that their paintings bccome far-fetched analogy. Through the Third Annual Exhibition of Chinese oil painting, it will be realized that oriental art road contains profound meanings. I am glad to see many of excellent oil painters have been exploring their art creations according to their unique understanding and pursuit to the art.

The Third Annual Exhibition of Chinese Oil Painting is an important symbol for the future that Chinese oil painting will break its new path. Finally, best wishes for a great success of this exhibition.

# Academic operation and commercial benefit

By Du Wen-bin

Oriental Art Gallery, as the sponsor of the Third Annual Exhibition of Chinese Oil Painting, has commercial consideration through purchasing all works shown in the exhibition,but I don't think it's contradiction between commercial benefit and academic objection. On the other hand,successful commercial intervention will secure academic operation in the position of high-grade and standardization.

Along with the change of economic system,artists can hardly like the past who create artwork depend on the periodical salary,which means the inexorable tendency of artwork's entering the market.At present,I'm keenly feel the great difficulty in consummating Chinese art market. Non-combination between commercial operation and academic objection,results in the lower taste of art market,that makes lots of painters only put their hopes on overseas purchasers.The purpose of our holding this exhibition,aims at producing the better academic condition for investing native art,meanwhile provide the opportunity of integrative show of academic achievements.

For a long time,it's rarely to see art investment with high standard and long term eye-sight,usually is the short-term investment for reaping staggering profits,so that art market is in a horrible mess.The people who are engaged in galleries have to keep going by painstaking efforts,hardly possess fund needs for exploitive and directive investment,but some opportunists without social consciousness and responsibility expert in making money by their speculative actions.It is without agency that makes Chinese painters have to spend more time and energy on searching for suitable purchaser for their artwork.

For the development of art,it's an abnormal circulation.Chinese art is needed someone to put money in assisting academic art.From commercial aspect,though pay off period of the investment may be for a long time,while with great potential revalue.I believe that this investment will obtain not only a satisfactory result, but an encouragement for men of insight joining the groups of art investment , at the same time, get the belief of artists: that is --- a perfect market circumstance must be a friend of art.

10,1995

# Farewell to the former exhibitions

By He Bing

Chinese oil painting exhibitions have been organized like the pattern of national art exhibition for more than seven or eight times since 1987.All these are past but play their major roles in the development of Chinese oil painting from that social environment.It's within the market economic system of 1990's and the condition of new system replaces the old,that some evils especially imperfect legal institutions;corruption and degeneration;inevitably appear and thus bring about some negative factors to the market economic system and art creation,while directly lead to the abatement of moral concepts and national pride,such as the admiring money worship.These unhealthy phenomena can gradually be overcome in the process of economic system reforms.Under such a situation,if we organize national art exhibition according as the pattern of planned economy,which the nation support in finance,Chinese artists' associations at different levels show their publishing prowess on the one hand,on the other hand invite adjusters composed by a group of specializers in oil painting as appraisers,can not far adapt to recent social situation.The confusion of Chinese art market system,results in parts of artworks have to yield only to popular taste of southeast Asia and be reduced to the material market and production base of western centralism. Some artists drift with tide,seeking fame and wealth rather than a lofty art spirit by their manufacture replace the creation.It is unexpectable that Chinese art market controlled by overseas has played an farce,which a mediocre oil painting was sold 800,0000 by commercial operation,as well as another traditional Chinese ink painting without vigor of strokes was drived up to 1500,0000.Surely doesn't it mean that we betray our dignity,ideal;spirit when we force up the prices of craftsmanly painting? It is more pity for those excellent painters surrounded by overseas dealers, who have no choice but to be the machine to make money.It's really a dual grieves for both our history and culture.Examine art creation from the art market system the same as do art education from the art creation, we have to think deeply about it. As a matter of fact, economic basis determines superstructure,then it's impossible for our art creation to cast off influences from overseas dealers,if we attach ourselves to it's market.This is only one aspect of problems.

Besides,the pattern of national art exhibition and evaluation can also not fit in with the needs of recent art idea and creation.Along with the change of economic structure,culture exchange and inspection to the west become very popular,it's unimaginable for us that traditional ideological grip on the arts has been broken to such a degree.How is it practicable like that pattern in art circle have continued for 10 years,which selection opinion and appraisal structure has still carried on as before?Especially none of us regard art as instrument of propaganda . Appraisal committee members comprised by more than 10 or 20 people are from different authority agencies, because  each refuses to give in to the others,cause sharply conflict idea,Contradictory of appraisal committee at the national art exhibition last year reveals this problem exactly.

The preparatory work for the Third Annual Exhibition of Chinese oil painting adheres to improving academic and exhibition levels. After careful consideration from different levels,the purpose of

our inviting critics to direct academic objection,aims in selecting representative works with lively connotation and inner spirit,meanwhile developing national art market system through collecting all selected works by enterprice.But it is only a ideal. In actuality,we have to face recent social and economic reality that opening market intervention is different from that artists sell their works directly to the overseas purchasers.It's certain that complicated and confusing Chinese art market can not smoothly devolop in a short time,and whether the stride is taken forward too big, is worthy of disscussing.

On the basis of academic and exhibition operation,we have been tried our best to obtain some advancements but still not jump out the pattern of national art exhibition.It is expected that some excellent works have not be selected and awarded for the appraisal committee losing their sharpness and dashingness in the judgement,though overall works at the exhibition are with high levels.

Even though,we have made remarkable achievements by collecting all selected works in this oxhibition cither in the quality of works or the academic operation .It is the crucial monent when history steps into the 21th century,that we must see the Third Annual Exhibition of Chinese Oil Painting as an inspiration of farewell ceremony to the past exhibitions.

# International Rules and Oriental Art Road --About the theme of the Third Annual Exhibition of Chinese Oil Painting

By Liu Xiao-chun

In my point of view,to emphasize oriental art road doesn't mean the negation of international rules,and vice versa.

The so-called international rules are some concepts and forms of the "general law" initiated by western modernism and postmodernism.This "general law" includes the following aspects in the field of oil painting in particular:

1.Special emphasis on the autonomy of artists, that is, stresses on individual independence and creativeness, which is not simply a matter of personal style, but, more essentially, the artists' unique and original understanding of life and art, and the challenges to the existed rules appeared in that process as well. Of course, this challenge should be distinguished as advances toward a higher level or just revolt of some minor schools,and as being of good quality or poor quality ,which,however is another problem. 2.Special emphasis on the autonomy of form,which means that,for paintings of both narrative type (such as historical painting,figure painting and symbolic absurd story painting, etc.) and non-narrative type (such as custom ,landscape,still life,animal,and abstract painting,etc.) narration is no longer the basic idea,but reduced to only a subsidiary approach to express spirits or even completely rejected (such as in abstract painting), while the form itself has become not only a direct means but also the main language of the expression of spirit.In other words,an artist will never be successful no matter how prominent subject matters he or she chooses to depict,if he or she is not able to create his or her own form language to communicate ideas.Otherwise,even though what he or she portrays are as common as a grass or a tree,still new pathes may be opened up for the development of Chinese oil painting. 3.Special emphasis on the autonomy of light, color, dot, lines,surface,volume and picture space,which means that for both realistic and abstract painting,reproduction is no longer the basic idea,but reduced to a subsidiary approach to express spirits or even completely rejected, while form in the classical sense has become not only a direct means but also the main language of the expression of spirit.In other words ,an artist won't be greatly successful, no matter how strong his or her reproducing ability is, if he or she is not able to create his or her own constitution language of light,color,dot,line,surface,volume and composition to communicate ideas.Otherwise,even though what he or she draws are as simple as a few lines,still

new pathes may be opened up for the development of Chinese oil painting.

4.Special emphasis on the autonomy of material, which means that for both pure painting in oil and borderline painting in oil and other various materials, medium is no longer the means of means, instead, the specific properties of knife, pen, oil, water colors, wood, paper, wax crayon and pastel have been transformed into important even basic approach for the expression of concepts and spirits, and simultaneously the acting process on these material like piling, scraping, picking, smearing, nailing, squeezing, pressing and pasting the communicative process of these concepts and spirits. It can be claimed that the process itself, in fact, is creation, is expression, is the spirit, and is the language. Therefore, even if he or she succeeds, the success must be a defective one, if the artist considers the process merely as a mechanical one aimed to fulfill the plan, and does not express concepts and spirits in the acts like piling, scraping, picking and meaning of knife, pen, oil and watercolors, etc. Otherwise, even with only a few seemingly casual strokes of pasting, scraping, piling and brushing, stiushing, stiushing, still new pathes may be opened up for the development of Chinese oil painting.

5.Owing to the forementioned reasons,the development of symbolic, expressionist, abstractionist and borderline oil painting,the confrontation between academicism and avant-garde,as well as the tendency of artistic multi-facet are all irresistable.

The so-called"oriental art road" refers to the advance of Chinese oil painting toward modern concepts and forms, and the inexorable creative modes and attainments different from the west in assimilating postmodernist doctrines. If the twentieth century can be said to be one in which Chinese oil painting is learning from Europe,then the next century will be one in which Chinese oil painting is a giant in the international art world with its independent Chinese spirit and oriental style. So it should be realized that now at the turn of the century it is a historical transition we are facing. Oriental art road is a process,a process in which Chinese artists,facing the clashing between the Chinese and western,the ancient and modern,struggle mentally and start new lives sincerely,and a process whose essence is creation,especially the creation of geniuses. The foregone path of the oriental art road is clearly discernible,but the possible future development is difficult to estimate,for creation is always beyond expectation.

The course that Chinese oil painting has taken is one neither designed according to centralism in western culture,nor following indiscriminately the pattern of national culture,which two opposites are often unexpectedly consistent with each other--the more enthusiastically Chinese culture presents its own distinctness,the more excitedly the western culture applauds condescendingly in seeking novelty in aboriginal cultures.On the other hand,the souls confronting to the real existence of China and the world are struggling by themselves in this craze for cultures with touristy attractions. Owing to the fact that as for a concept,the larger its denotation,the smaller its connotation,the title "oriental art road ",similar to those terms like "nationalization",lacks a specific practical sense due to its extensiveness in meaning.However,if being understood in a too specific and practical way,it will only become the shackle of imagination leading to vulgar and superficial creations.Consequently,only in cases with particular direction does this term gain practical values.For instance,in the Venice Biennial Art Exhibition 1993,the theme of the Chinese show room,where paintings mainly of political pops and cynical realism are displayed, also is "oriental art road", which is only a narrowed concept in westerners' point of view .The Third Annual Exhibition of Chinese Oil Painting has borrowed this theme word with the intention to change its using context.In my opinion,the tenor of the course of Chinese oil painting can only be accurately grasped by Chinese people themselves.

Obviously, it is a misunderstanding to recognize all the works which have accepted some concepts and forms of modernism and post-modernism as being "cooidentalized",

for what the term "oriental art road" mainly refers to is the creation of modern civilization with Chinese spirit and oriental style,and in oil painting this particular field,the Chinese oil painting with modern forms and styles and those assimilated post-modernist ideas.

Following the footsteps of the older generations of oil painters, a new generation of middle-aged and young artists are exerting themselves for the creation of new Chinese modern civilization, with them, oriental art road is full of hazard and bewilderment, but also glamour and expectation.

# Oriental Art Road ----The past and the future

BY Pi Dao-jian

The msot significant deviation of the Third Annual Exhibition of Chinese Oil Painting from the former two, is that invited to the exhibition are not only a large number of outstanding painters with their best works, but also wellknown critics with diverse academic views and critical criteria to take part in the planning and appraising process. Though operating in a commericialized fashion, the exhibition this year has conspicuous academic orientation which is revealed in its theme---oriental art road, manifesting that what the exhibition is concerned about is the current state of Chinese oil painting creation, as well as the past,present and future of this art form reflected in it. And undoubtedly, the main idea of the exhibition is to demonstate an independent spirit with Chinese characteristics and an open cultural attitude facing to the new century.

In fact, this academic theme has been thoroughly displayed in the 120 exhibited paintings selected by the academic committee comprised by critics, painters, collectors and activists according to the agreed rules through continuous discussion in three phases during half a year.In particular, fully and vividly reflected in the exhibition about Chinese oil painting is its arduous course assimilating western culture over a whole century, and the academic achievements attained in the present period.

Since nineteen twenties and thirties--a violently changing period with the transforming of the Chinese society into modernism, and the clashing between eastern and western cultures,Chinese oil painting has always been the field of the broadest cultural views,the keenest artistic sense and the fullest creating energy.Its development is closely related to each of the prominent advances of Chinese modern art,from the sharp conflict between the new and the old ideas about human figure drawing since twenties,to the series of arguments in seventies and eighties about artistic form,realism and modernism,artistic language,and so forth.Almost every reform in the artistic field has oil painters and theorists being concerned with oil painting acting as the pioneering and backbone elements.It is the forementioned arguments and practices in oil painting creation associating with them that have promoted the development of Chinese oil painting. Therefore the aim of the annual exhibition this year with oriental art road as its academic theme is to present the historical changes in this course of development through the representative works of various styles,schools,creating ideas and techniques in current oil painting production.

Simultaneously,in the exhibition this year both some of the finally exhibited works and some of the unselected ones have strikingly reflected the current situation of Chinese oil painting production as well as its new views,new senses and new language structures,all of which are naturally the main concern of critics.These paintings,challenging our senses sharply with their openness in language structure and their obscuring of the traditional categories of oil painting,are manifestation of the consciousness of artists,who have broken away from the old language pattern of oil painting and the stand of parochial nationalism,to participate actively in the contempory world culture.Some excellent painters,having overcome their morbid psychology and behavior caused by the repellence to western centralism,now are able to observe and handle contemporary issues calmly and confidently from a modern Chinese point of view.Some of their paintings have already been a part of the present world artistic trend,and have astonished and won respect from the international art world with their high artistic standard,such as Shi Chong's "Gratified Young Man" which conveys with a heart-shaking effect the facing to the undisguised human nature,and  Shi Lei's "On perception " which represent a keen grasp of the present living situation of human being. Besides, some younger artists like Tang Hui express themselves in an utterly relaxed way,which painters of the older generations have never possessed. Shi Chong's transfering of action,apparatus and ready-made material to pictures and Tang Hui's integrating of visionary images are sincere attempts to guide reality with their innermost being and artistic intuition.Therefore to a certain extent the passion poured into these paintings are more significant than the ideas embodied in them.

As perfection is always difficult to attain,painting selection in the annual exhibition also leaves over some pities,for not only some outstanding works with the abovementioned remarkable traits have been excluded from the exhibition,but also the rating of selected paintings for award has not reflected necessarily the active response to the present state of oil painting creation.In a strict academic sense, appraising in the exhibition this year has laid too much stress on the past of the course with Chinese characteristics,while lacking sufficient sensitivity to its future development.Though the organizing committee has endeavored to invite more critics to take partin the painting assessment,owing to  the mere one third proportion of critics in the appraisal committee,and the decline of art criticism itself,critics have not played an as important role in the exhibition as they should do.

# To be an artist should have ideal and Pursuit

By Shao Da-Zhen

It's important that Chinese oil painting,either the realistic or the other styles,continue to improve painting technique,for the immature of technique has become the popular defect for all Chinese painters.But I think the main concern is that the artwork is deficient in emotion and inner spirit rather than the technique.

Emotion and spirit is the soul of artwork, directly influences the success or failure of every work. Artists often rely on medium and technique to express their feelings and thoughts, so that is a permanent subject for them to study different medium and technique.But it is certain that these pure oil painting techniques will lose their senses if without deep ideas and sincere feelings. Under such a condition, that the affectedness of manner and some styles purely depend on medium and technique become popular.

Western modern art has been gradually known and understood by our artists and people. As a whole, some defects and lessons are from the styles of modernism,but its' spirit,critic spearhead,distinctive attitude focus on the reality are the quality we have to learn,while our evading and giving up some nihilism opinions.Since two years, a kind of inner spirit we have found in the works of Jiang Zhao-he,Xu Beihong, Wang Shi-kuo, is precisely from their showing solicitude for society and reality, It is important character of our realistic art since the May 4th Movement (1919)and we should carry forward the good traditions.

It's noticed by me that some of artist's works are shortage of somewhat,a kind of lively spirit.Maybe some artists live their lives too ease to face realistic and social life. These painters indulge themselves in juggling with painting technique,so callded"deepen the study of painting language".As a result,the audiences remain indifferent towards their artworks because of pale and weak of art language.

As a painter,on the one hand,distinctive character is needed,on the other hand he should respect the art regulations when he gives free rein to express feeling and affection.If artists follow their inclinations to let off characters,will result in beautiful soap bubble in their oil paintings.

In our art circle, a pressing matter of the moment is to improve the accomplishment and quality of artists.

# To view Chinese Oil Painting through three Annual Exhibitions

By Jia Fang-zhou

The Annual Exhibition of Chinese Oil Painting from the 1st(1991) to the 3nd (1995) has strided across 5 years.The way of continuous exhibition presents not only the evolution of art at a certain period, but also the growth and development of painters, who take part in this exhibition.And the value of the exhibition lies in promoting the new artist by giving different awards. Comparing roughly the three annual exhibitions, we can see some changes and the tendencies of Chinese oil painting :from classical style into emotional expressionism;from realistic skills into that combined with idea;from painting of Chinese custom into thinking of real life;and from realism into abstractiveness; from oil painting language into material language, and so on, All these are the obvious characteristics of this annual exhibition. It is easy to see that the evolution of art is the pervasive course to the new realistic territory,at the same time also the course to adjust itself. The tendency what Chinese oil painting yields to commercial popular taste in recent years has been deeply corrected in this exhibition. But like '91 and '93 annual erxhibitions,the purity of academicism is the objective of this annual exhibition, typical academic mode will you find in the works that was given the prize. Under the "major

premise" the face, the work "Ming style" painted by Wang Huaiqing is given the gold medal, builds up the high academic standard at the first annual exhibition. From some awarded works,you will see distinctive styles,"Ming Style" by Wang Huaiqing;"The Seductress" by Li Tianyuan;"Kaifeng, November12, 1969" by Zhou Xianglin;" Dried Fish ", "A Walking Man" by ShiChong; "Pink Flowers" by Chen shuxia;" Mother and Child" by Yan Ping; "The Red Scarf" by Chen Wenji; "Reflection" by Hu Jiancheng,and so on ,are the representative works in this period, these works are the good examples illustrating how Chinese painting melt the traditional, how to express the sense of contemporary person, how to rich in individual character, but it is difficult to include some most active artists and their experimental art works because of the joining this exhibition by the official. Either in politics or in commodity, the limitedness is existing even if critics are in charge of the exhibition. In spite of some sensitive subjects and some skills that surpass the tradiational boundary have to be evaded, the success of Annual exhibition of Chinese Oil Painting lies in not only the sharpness of thinking and pop thinking but also its promotion of the development of academicism in chinese contemporary oil painting and

provides the opportunity for new painters by giving them the highest prize.

The significance of this exhibition in the development of Chinese contemporary oil art will not be neglected.Many of the young painters show their achievements by taking part in this continous exhibition.Some who have joined the 1st and 2nd Annual exhibition,got award and even the great award this year,such as Xu Xiaoyan,Yang Chengguo,xin Dongwang,Gong Lilong, Su Dongping, Yuan Xiao fang,Gu Liming,Wu Weijia.Other painters got "Special invitatee" such as Cai Jin,Yu Hong.And others are awarded continously,Shi Chong,Leng Jun,Yan Ping, Hong Ling.Among them, Shi Chong is a typical character.

Shi Chong,takes part in all the three exhibitions .He is awarded silver medal (for Fried Fish) in the 1st annual exhibition,gold medal (for A Walking Man) in the 2nd one, and silver medal (for Gratiified Young Man) in this 3nd one. In recent years,Shi Chong is making persistent efforts in grasping human feelings and thoughts and their existence.In the 1st exhibition,he paints a fried fish with excellent skills to express the trace of material life;in the second exhibition he makes individual exploration on the subject of humanity by his work "A Walking Man",in this exhibition he makes self-examination in human existence and living condition.In the work "Gratified Young Man",Naked man and skinned quail,especially the red eyes of that man cause trembling feelings in viewers .The work by Shi Chong brings about a strong sense of guilty in my mind ,but it is regretful that some of us never make self-examination,which we should do.Also of equal importance are the good skills,and deep thoughts in his works.

Len Jun keeps pace with Shi Chong.They both are from Hubei province and appear at the same time.In three exhibitions,the works by Leng Jun are "Bond and Wood","Net-A Design about Net","Century Landscape".The first work has no profound meaning but purely realistic skill.In contrast with another two works in this same period,"Story of Barn lantern" doesn't get rid of superficies though dipicting a plot bestowed with a revolutionary theme.It is from "A Boundle canvas" that something ponderable starts to appear.And "Net-A Design about Net" is evocative of the new trend of realism conbined with idea.From the work "Historical relics--A Design of New Product",Leng Jun expresses his worries and reflections by a world map welded by a pile of industry rubbish with strong visual sense.

In contrast with the realistic representatives Shi Chong and Leng Jun,some painters is seen as the leading figure of expressionism:such as Shen Ling,Yan Ping,Xia Junna,Deng Jianjin,Su Dongping,Wang Yuping,Liu Daming,Yu Zhenli,Zhang Guolong,Mo Hongxun,who obtain a poetic amalgam of abstraction and reality to reflect the pulse of life.Xu Xiaoyan is between the two trends. Among the invited Chinese Female Artists.I am glad to notice the emergence of her series works "Autum Landscape". Compared with the work of the former exhibition, her work in this exhibition makes amazing progress.If Leng Jun shows an interest in composition and volumes rather thanbrushwork, then forceful brushstrokes are her preference.She portraits plain nature with vigorous burshstrokes and patches,and crestes an expression with artistic charm.Her painting has the charisma of oil painting.and she will be a new painter be deeply concerned about after the two exhibitions.

Another achievement and characteristic of this exhibition is its tolerance of different styles especially the "Boundary Form of Oil Painting".Material intervenes in oil painting,and changes its creative composition and

language.Liu Gang's use of metal,Xu Hong's cobble and Chinese paper,Duan Jianghua's cloth and board,Cai Jin's mattress instead of cavas , and Liu Liping's big painting containing a small painting,Mo Hongxun's another painting existing outside the real painting (that is emphsis on the power with frame),all of them explore the expressive creation by material language as well as oil painting language.The experiments of these painters enrich the creation of oil painting,and meanwhile find a greater space for them to express their creative ability.

The Annual Exhibition of Chinese Oil Painting has become the territory where younger generations show their maturities and achievements on art.The organizers will be justly praised and recompensed for their contributions in keeping this exhibition.

# Urbanization tendency in Chinese oil painting and human dignity in urban culture

By Wang Lin

If primitive art is anthropological,classical art sociological, modern art morphological,then contemporary art obviously is culturological.The transformation of contemporary culture can be analysed in various aspects,such as its overlap and mutual promotion with traditional culture,the differentiation and mergence of cultural strata,the difference and relationship among regional cultures,and so forth. However, as for the Chinese oil painting after the year 1989,the most significant change is the sudden rise of the tendency of urbanization.

As far as oil painting is concerned,the main a  evement of Chinese fine arts in 1980s is local painting,whi      ically introspects social realities and historial issues        t- aneously,new trend fine arts as anti-traditional c movement with more importance attached to indi consciousness starts to depict the living circumstance and mind state of urbanities,but is still far from comprehensive penetration into urban life and true reaching of the essence of urban culture issues.After the year 1989,a large group of young artists,giving up their pursuit of social responsibility and cultural ideal, carried on the individual consciousness characteristic of new trend fine arts and

oriented to the portrait of the individual real life and living circumstance,and further to that of urban cultural forms.This transformation is consistent with the trend of world culture,especially that of Chinese culture after 1990. In contemporary society, owing to the concentration of administration,technology and population, especially information, media and consumption to urban areas, cities have become the center of diverse cultural consciousness,cultural rights and cultural trends. In essence, contemporary culture is an urban culture and one spreading from urban areas to countryside,leaving no possibility for the reoccurrence of "encircling the cities from the rural areas".Urban residents are facing new problems about existence,spirit and culture,for since 1989,due to the opening of Chinese society and popularization of public media,people have been placed into a world flooded overwhelmingly with information, consumptionism and popular culture.And it is from this background circumstance that the tendency of urbanization in Chinese oil painting comes into being.Chinese artists experience never so deeply the attractiveness and morbidness of urban culture which are brought about by the swift and violent development of Chinese cities and the abnormal

transformation of urban culture based on the special opportunity and the economic miracle,and thus,with their own strong and profound individual spiritual responses to it,may be able to contribute to the world modern art.In fact,Chinese painters have already started to alter their former image of expressing the state of affair after the cold war and demonstrating the condition of human rights.Surely with the deepening of the tendency of urbanization and the increase of communication with foreign countries, Chinese artists will become an important force in contemporary international artistic activities.

The most important point for artistic creation in this tendency is not to present urban life and the living situation of urbanities as the subject matter,but to express unique feelings,sensitive psychology and preeminent wisdom in production,that is, to treat critically and ponder introspectively the present cultural facts,to reflect the contradiction between life needs-the needs of individual spirit for dependence, richness and continuous development,and present cultural situation,to transcend the reality and ideology implied in it, and thereby promote the cultural development towards the destination to enrich people.As result,urbanism painting should be on the alert against opportunism characterized by the indiscriminated following of general trend and cynicism characterized by unconstrained consumption and entertainment,for to jokingly dissolve seriousness,when directed to idealism,may be either a mock of the political hypocrisy or betrayal of spiritual truthfulness.Consequently,I don't mean to negate the cynical urbanization tendency in a general sense (quite a few works are extremely forcefully critical and spiritually instructive), but only to be wary of those paintings whose producers are self-amused by,self-indulged in and self-satisfied with the cynicism in them.Furthermore,if the cynicism is directed to some valueless and out-of-date political ideal,then it can provide nothing spiritually new,but instead hides the ideologies and cultural norms implied in daily life.That is to say,what it is trying to eliminate

is the right of the need for spiritual independence,richness and development,which is also a human right in a more profound sense.In fact,popular culture has become "smiling facism" for the voluntary group approval it receives ,and artists giving up the ideal and the power of human dignity in the cultural reality,can only be the smiling captive of this facism.While on the other hand ,no matter how Dadaism and popart exploit artistic resources in both the world of reality and the world of life, art as the symbol of spirit can be neither the mere representation of material life nor that of daily life.According to the full demonstration of the essence of art itself in modernism, artistic issues are, in fact, issues of human being, and at present the issue of urbanism.

In this picture album, readers can see quite a few paintings attending to the issue of urban culture, and feel the sensitivity, surprise,realization and criticism of these artists concerning the living state of urbanities. Just among the awarded works, for instance, a group of excellent paintings like "Gratified Young Man" by Shi Chong; "Studio" by Shen Llng; "The visitor" by Deng Jianjin; "The God fioated by" by Guo Jin; "What do we need?" by Yang Guoxin; and so on, which are deeply impressive,have brought about a radical change to the cynicism-favoring state of urbanism painting. With these outstanding artists and those who haven't participated this exhibition but have already made remarkable accomplishments in urbanism painting (such as Shang Yang,Zhang Xiaogang,Liu Wei andLiu Dahong,etc), it is highly expectable that Chinese fine arts in 1990s will attain new and independent artistic achievements,for which oil painting is only one form of the media.

# Debate about the Gold Award Works

By Peng De

Usually art exhibitions with an appraisal committee comprised by a group of people may do greater harm to artistic creation than those presided over by one person.The reason is that sense of responsibility is apt to fade away in the tendency of following the general trend or in the context of an emotionalized argument. It is a common case that an appraisal meeting for talk offhand is turned into the process of picking faults in tiptop works ,or even the place where these innovative and talented ones are strangled. It is a typical example for gold-award deciding that Shi Chong failed in the last round of vote,though when ballots for his painting ranked the highest together with those for Leng Jun's in the former rounds ,it was generally believed that there was no work that could match these two.

Shi Chong is an artist having achieved success and won recognition at home,whose development has strong logic in itself .He starts the practice of apparatus art oil painting, which has developed into a new influential school in Chinese oil painting circle.Now, at the time when action art oil painting has become a common practice,he has every reason to be the one rewarded .The selection of gold award works should take into account not only the picture itself,but also the producer, that is the painter's actual strength, qualification and potential, especially in cases of endless debates.

The popular pattern for deciding on award in national art exhibition is aimed to reflect, by the three gold award winning pictures,the multi- facet of artistic forms or even themes which,however, has already been presented in the whole exhibition.In actuality, it is impossible for gold award winning works to take on this heavy responsibility in the aspect of artistic policy.Assuming only one painting can be awarded,can it be said that only one which is a mixture of all these diverse forms and themes can win the prize?

The emphasis on artistic policy has removed the paintings', artistic achievements to a secondary position in award-deciding. The picture "Drama • Three countries " and " Autumn scenery" though outstanding,lack sufficient reasons for receiving the first prize. The former, which is a work full of wisdom, and mockingly discloses the absurdity of a course with Chinese characteristics achieved by means of restoring the ancient ways, still has not attained a high degree of technical proficiency in handling the picture space.The latter, whose picture space handling is loose and free on the one hand,solid and forceful on the other,displaying the talents of its producer,only skillfully meets the technical requirements of academicism. Consequently it still needs further inspection to see if the two new painters will become great talents, and so to place them in suitable position is more beneficial to their self- warning and self- improvement.Promotion of new artists with no convincing reasons, which is a common failing in current art exhibitions, is a mock of artistic creators resulted from equalitarianism.It not only hinders the

excellent artists from their orderly development,but also suspends the progress of fledgling young painters, which will finally lead to the scantiness of excellent personnels in Chinese art circle to march Into the international art world.

Though both Shi Chong and Leng Jun's paintings belong to the realistic style, the difference between the two is evident: the former is still life,while the latter figure painting, the former belongs to apparatus art oil painting,the latter action art oil painting, the former is classical, the latter innovative.The former reveals the paradox of civilization- the world decline due to industrial civilization, the latter the hypocrisy of civilization.In Shi Chong's painting the exquisite technique and penetrating analysis of human nature stimulate both the visual sense and the soul of the audience.The skinned quail,which is an indication of tranquility and peacefulness, together with the human body coated forms a sharp contrast, symbolizing the opposition between white washing and disclosing, and brings about both a spiritual conflict and an embarrassed feeling. It is a painting that no one capable of introspection facing it will keep calm .But, at the critical moment,the appraisal committee came to a conclusion that is unexpectedly fallacious.

# 第三届中国油画年展参展作品名单
## List of the  Third Annual Exhibition of Chinese Oil Painting

**金奖：**

1·冷 军《世纪风景》

2·杨成国《戏剧·三国》（三联）

3·徐晓燕《秋季风景》

**银奖：**

4·石 冲《欣慰中的年轻人》（《江苏画刊》新人奖）

5·申 玲《午后懒洋洋的小女人》

6·夏俊娜《秋》

7·忻东旺《诚城》

8·阎 萍《母与子》

9·邓箭今《来访者》

**铜奖：**

10·宫立龙《婚纱》

11·刘丽萍《金玉米·金玉米局部》

12·刘大明《北海·假日》

13·杨国新《泼水节印象》

14·苏东平《怀疑·嫉妒·厌倦
　　　　－关注鲍依斯的人们》（三联）

15·洪 凌《翠谷幽潭》

16·刘国新《抛物线》

17·李延洲《冷寂冬日》

18·郭 晋《飘过的上帝之一》

19·郭润文《梦归故里》

20·陈淑霞《阳光留驻》

21·杨国辛《我们还需要什么？》

**佳作奖：**

22·徐 虹《穿越四季》（四联）

23·唐 晖《时间机器》

24·吴维佳《战士》（三联）

25·莫鸿勋《封存一团快破碎的记忆》

26·于振立《断念·小写三·搁置》

27·胡朝阳《阵雨》

28·张国龙《黄土》

29·秦秀杰《云》

30·井士剑《圆明园》

31·顾黎明《门神－线板·色板NO·18》（二联）

32·贾鹃丽《煌》

33·陈 曦《仿膳》

34·袁晓舫《"战斗"－飞行计划》

35·郭正善《静物》

36·徐安民《THE　WORK　S2－9号》

37·王清丽《母亲湖》

**入选：（不分名次）**

**Gold Award:**

1.Leng Jun　　Century Landscape

2.Yang Cheng-guo　　Drama · Three Countries

3.Xu Xiao-yan　　Autumn Landscape

**Silver  Award**

4.Shi Chong　　Gratified Young Man

5.Shen Ling　　A Little Languid Woman in the Afternoon

6.Xia Jun-na　　Autumn

7.Xin Dong wang　　Honest

8.Yan Ping　　Mother and Child

9.Deng Jian-jin　　The Visitor

**Bronze Award**

10.Gong Li-long　　Wedding clothing

11.Liu Li-ping Golden corn

12.Liu Da-ming　　North Sea · Holiday

13.Yang Guo-xin　　Impression of Sprinkling Water Festival

14.Su Dong-ping　　Distrust · Jealous · Tired
　　　　--the People Pay More Attention to Boyes

15.Hong Ling　　Deep and Serene

16.Liu Guo-xin　　Parabola

17.Li Yan-zhou　　Cold Winter

18.Guo Jin　　The God Floated by

19.Guo Run-wen　　Dream of Returning Home

20.Chen Shu-xia　　Sunshine

21.Yang Guo-xin　　What Do We Need

**Excellent  Award**

22.Xu Hong　　Cross the Four Seasons

23.Tang Hui　　Time Machine

24.Wu Wei-jia　　Soilders

25.Mo Hong-xun　　Seal Off Memory of Mass Crashing

26.Yu Zhen-li　　Idea · The Third · Put Aside

27.Hu Chao-yang　　Shower

28.Zhang Guo-long　　The Yellow Land

29.Qin Xiu-jie　　The Cloud

30.Jing Shi-jian　　Roral Palace

31.Gu Li-ming　　Door God

32.Jia Juan-li　　Brillian

33.Chen Xi　　Classical Restaurant

34.Yuan Xiao-fang　　Battle--Flying Plan

35.Guo Zheng-shan　　Still Life

36.Xu An-min　　The Work S2-9

37.Wang Qing-li　　Mother Lake

**Selections**

３８·陈海鹏《空间》

３９·赵　竹《虹之后·勋布景·清灯》（三联）

４０·刘　刚《遗迹》

４１·姚　永《扎西得勒》

４２·宁方倩《潮中之鸟之六》

４３·谭涤夫《深秋的山谷》

４４·孙世伟《仙人掌》

４５、庄　威《江南春晓》

４６、谢建德《西部风景－城市二》

４７、韩大为《红色气球》

４８、燕　杰《挤奶妇》

４９、王克举《农妇》

５０、赵宪辛《北京·老外》

５１、张宏伟《投影》

５２、王占武《解放》

５３、马　俊、赵　琨《重塑》（三联）

５４、许　敏《秋实》

５５、叶恒贵《空中大飞机》

５６、赵文华《园地》

５７、赵箭飞《平仄系列之四》

５８、雷　双《白色花束》

５９、胡骏荣《斜靠着椅子的燕子》

６０、朱新建《生涯》

６１、刘　明《'９４夏日海滩第三回》

６２、金　田《净》

６３、丁　方《东方之路》

６４、梁　彪《家》

６５、陆成刚《拾穗》

６６、陈卫闽《风逊》

６７、李毅松《工业脊梁》

６８、毛岱宗《山村冬市》

６９、任建成《童年梦系列之一——游行》

７０、王利丰《"真"系列组画》

７１、王沂光《听春》

７２、曹吉冈《秋山野意》

７３、任　戬《人体档案之三"亚丽安娜－Ｘ底片"》

７４、翟　勇《苗年－系列组画之一》

７５、张　澎《联作之一，小凤儿，今年整十八》

７６、王朝斌《自语》

７７、张　晖《傍晚》（三联）

７８、俸正杰《皮肤的叙述·红双喜》

７９、韦博文《陶乐·地声·天谷》

８０、舒　群《同一性语态：一种后先锋主义？》

８１、林菁菁《风景断章》（三联）

８２、张永旭《小夜曲》

８３、韩　雄《合影１９９５》

38.Chen Hai-peng　　Space

39.Zhao Zhu　　After the Rainbow·Scenery·Light lamp

40.Liu Gang　　The Trace

41.Yao Yong　　Za Xi De Le

42.Ning Fang-qian　　The Fashion

43.Tan Di-fu　　Deep Autumn Valley

44.Sui Shi-wei　　Cactus

45.Zhuang Wei　　Spring in the South

46.Xie Jian-de　　West Landscape-City No.2

47.Han Da-wei　　Red Balloon

48.Yan Jie　　Milking Woman

49.Wang Ke-ju　　Village Woman

50.Zhao Xian-xin　　Beijing Foreigners

51.Zhang Hong-wei　　Projection

52.Wang Zhan-wu　　Liberation

53.Ma Jun , Zhao Kun　　Creation Again

54.Xu Min　　Autumn Harvest

55.Ye Heng-gui　　Big Airplane in the Air

56.Zhao Wen-hua　　Garden

57.Zhao Jian-fei　　Stright and Oblique Series NO.4

58..Lei Shuang　　White Flowers

59.Hu Jun-rong　　Yan Zi Sits in the Chair

60.Zhu Xin-jian　　Career

61.Liu Ming　　The Third,On the Summer Seabeach in 1994

62.Jin Tian　　Silence and Ease

63.Ding Fang　　Road to the East

64.Liang Biao　　The Home

65.Lu Cheng-gang　　Glean Wheat

66.Chen Wei-min　　The Wind

67.Li Yi-song　　Industry Back

68.Mao Dai-zong　　Winter Market in the Mountain village

69.Ren Jian-cheng　　One of Child's Dreams--Parade

70.Wang Li-feng　　The Real

71.Wang Yi-guang　　Hear the Sound from Spring

72.Cao Ji-gang　　Autumn Mountains

73.Ren Jian　　The Third Human Body's File "Alyanna-X Photographic Plate"

74.Zhai Yong　　The Festival of Miao Nationality

75.Zhang Peng　　In 1995,Xiao Feng--is Exactly 18 Years Old

76.Wang Chao-bin　　Talk to Oneself

77.Zhang Hui　　At Dusk

78.Feng Zheng -jie　　Skin's Narration -Double Happiness

79.Wei Bo-wen　　Pottery·Earthquake Sounds·Heaven

80.Shu Qun　　Identity Voice--One Kind of Postvanguardism

81.Lin Jing-jing　　Part of Landscape

82.Zhang Yong-xu　　Serenade

83.Han Xiong　　Group Photo in 1995

84、康笑宇《太阳雨》

85、刘 剑《95·面孔》

86、江 海《都市结构》

87、董文胜《成人游戏·2号》

88、张延刚《妆》

89、何 森《手的图象》

90、韩 冬《檀香木的室内》

91、陈树中《野草滩镇十字口》

92、李邦耀《我们》

93、朱 进《晚宴》

94、吕 鸿、张 昕《九十年代大工业
　　　　　　－鞍山钢铁公司系列之一》（三联）

95、王云鹏《秋日印象》

96、袁文彬《灵子》

97、陈少峰《国际标准》（四联）

98、王卫东《永存的记忆》

99、蔡 锦《美人蕉66》

100、王玉平《鸟·人》

101、夏小万《跌落》

102、白 明《物语》

103、张志坚《情思》

104、曲 欣《自行车》

105、陈绿寿《山庄的喜悦》

106、傅剑锋《脉－系列组画》

107、段江华《天门》

108、段正渠《黄河船夫》

109、段建伟《少年》

## 主办方特邀参展：

110、石 磊《论感知》（《江苏画刊》新人奖）

111、张洪波《二十一世纪雅尔塔会议》（三联）

112、任思鸿《记'94夏为一个女孩的生日》（二联）

113、廖邦明《褪色红布－新偶象》

114、谢恒星《康巴女》

84.Kang Xiao-yu    Sunrain

85.Liu Jian    1995·Face

86.Jiang Hai    City's Construction

87.Dong Wen-sheng    Adult's Game No.2

88.Zhang Yan-gang    Dressing

89.He Sen    Illustration of Hands

90.Han Dong    Sandalwood

91.Chen Shu-zhong    The Crossing of Ye Cao Tan County

92.Li Bang-yao    We

93.Zhu Jin    Dinner

94.Lu Hong, Zhang Xin    90's Industry --Anshan Steal
　　　　　　Co.One of Series Painting

95.Wang Yun-peng    Impression of Autumn

96.Yuan Wen-bin    Ling Zi

97.Chen Shao-feng    International Standard

98.Wang Wei-dong    Permanent Memory

99.Cai Jin    Canna No.66

100.Wang Yu-ping    Bird·Human

101.Xia Xiao-wan    Fall

102.Bai Ming    Natural Language

103.Zhang Zhi-jian    Affection

104.Qu Xin    Bicycle

105.Chen Lu-shou    Joyous of Mountain-village

106.Fu Jian-feng    Arteries and Veins

107.Duan Jiang-hua    Door of Heaven

108.Duan Zheng-qu    Boatmen in the Yellow River

109.Duan Jian-wei    Early Youth

## Invited painters by the organizer

110.Shi Lei    On Perception

111.Zhang Hong-bo    The Meeting of 21th Century in Yalta

112.Ren Si-hong    For a Girl's Birthday in the Summer in 1994

113.Liao Bang-ming    The Red Clothing is Fading--New Idol

114.Xie Heng-xing    Kang Ba Girls

第三届中国油画年展组织委员会

COMMITTEE OF THE THIRD ANNUAL EXHIBITION OF CHINESE OIL PAINTING

1995.11.17

图 版

PLATES

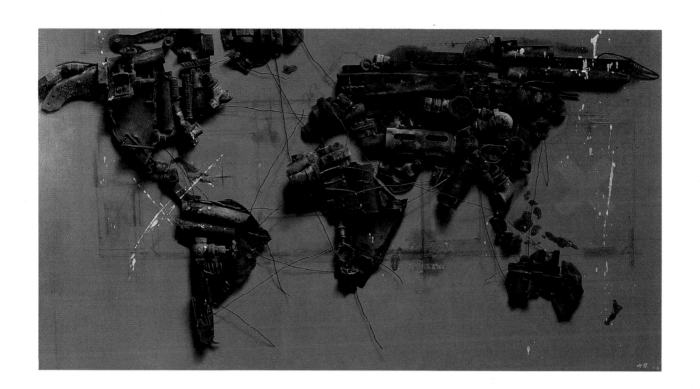

1. 冷军《世界风景》　金奖　Leng Jun　CENTURY LANDSCAPE　Gold Award

105X200CM

2. 杨成国 《戏剧·三国》　金奖　Yang Cheng-Guo　DRAMA.THREE COUNTRIES　Gold Award　175X360CM

3. 徐晓燕《秋季风景》 金奖 Xu Xiao Yan AUTUMN LANDSCAPE Gold Award

160X160CM

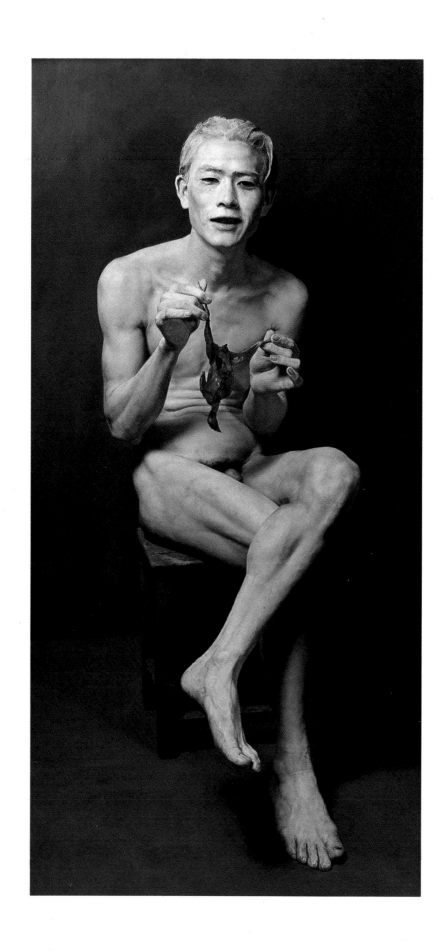

4. 石冲《欣慰中的年青人》 银奖 Shi Chong GRATIFIED YOUNG MAN Silver Award 154X75CM

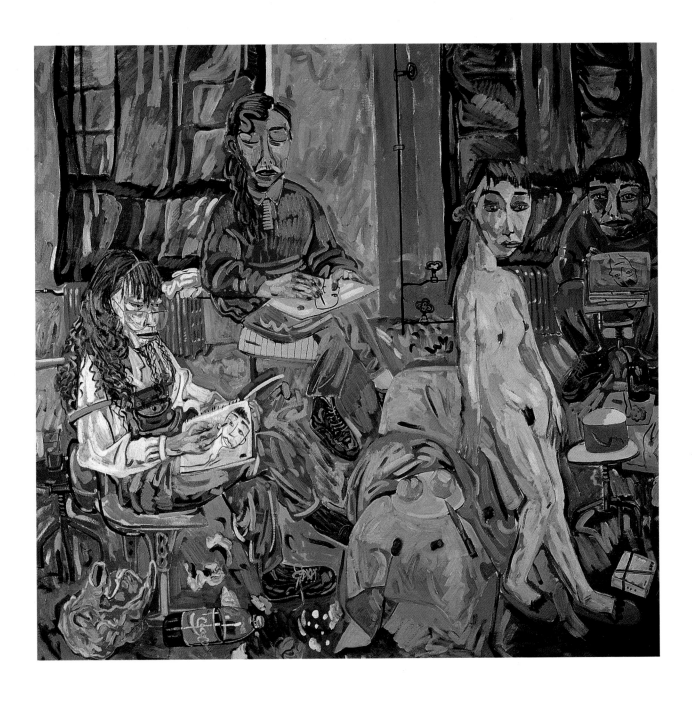

5. 申玲 《午后懒洋洋的小女人》 银奖 Shen Ling ALTTLE LANGUID WOMAM IN THE AFTERMOON Silver Award 190X200CM

6. 夏俊娜 《秋》 银奖　Xia Jun-Na　AUTUMN　Silver Award

162X261CM

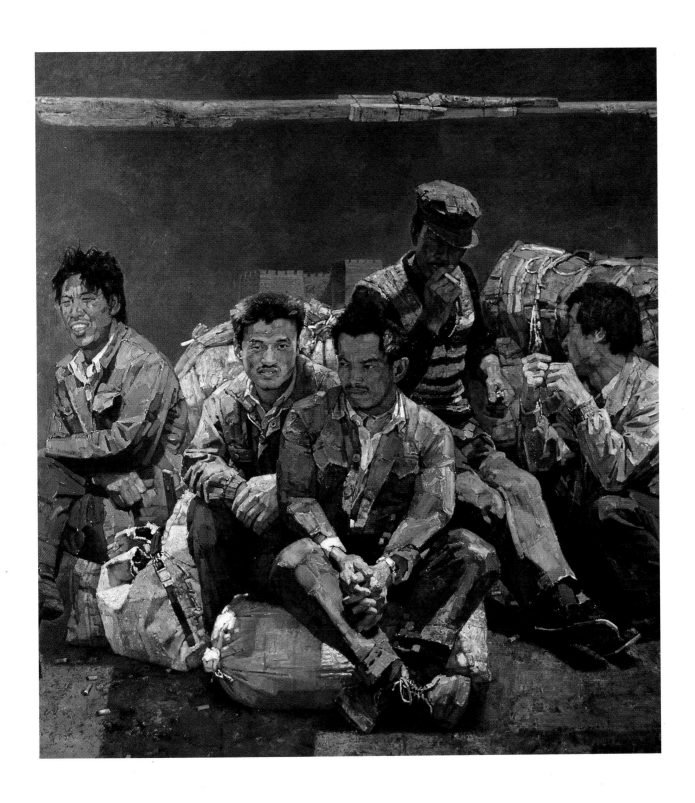

7. 忻东旺 《诚城》 银奖　Xin Dong-Wang　HONEST　Silver Award

160X150CM

8. 阎萍 《母与子》 银奖　Yan-Ping　MOTHER AND CHILD　Silver Award

120X120CM

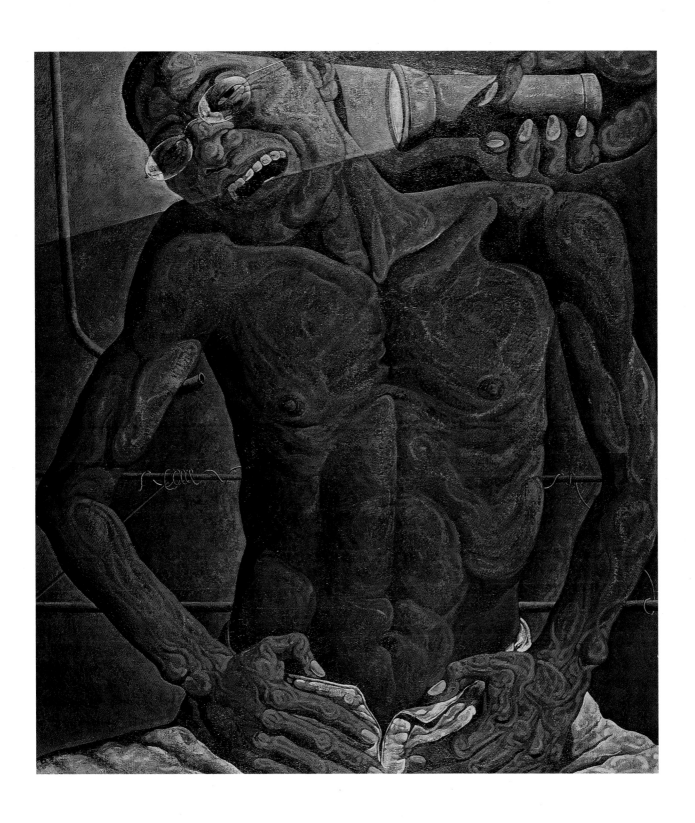

9. 邓箭今 《来访者》 银奖　Deng Jian-jian　THE VISITOR　Silver Award

186×160CM

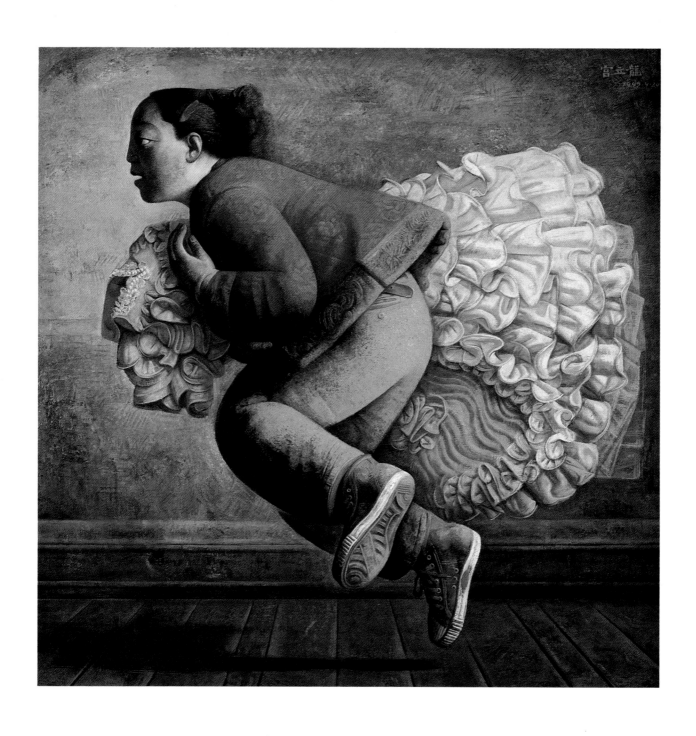

10. 宫立龙 《婚纱》 铜奖　　Gong Li-long　WEDDING CIOTHING　Bronze Award

160X160CM

11. 刘丽萍《金玉米·金玉米局部》 铜奖　　Liu Li-ping　GOLDEN CORN　Bronze Award　　130X194CM

12. 刘大明《北海·假日》 铜奖　Liu Da-ming　NORTH SEA•HOLIDAY　Bronze Award　　　130X180CM

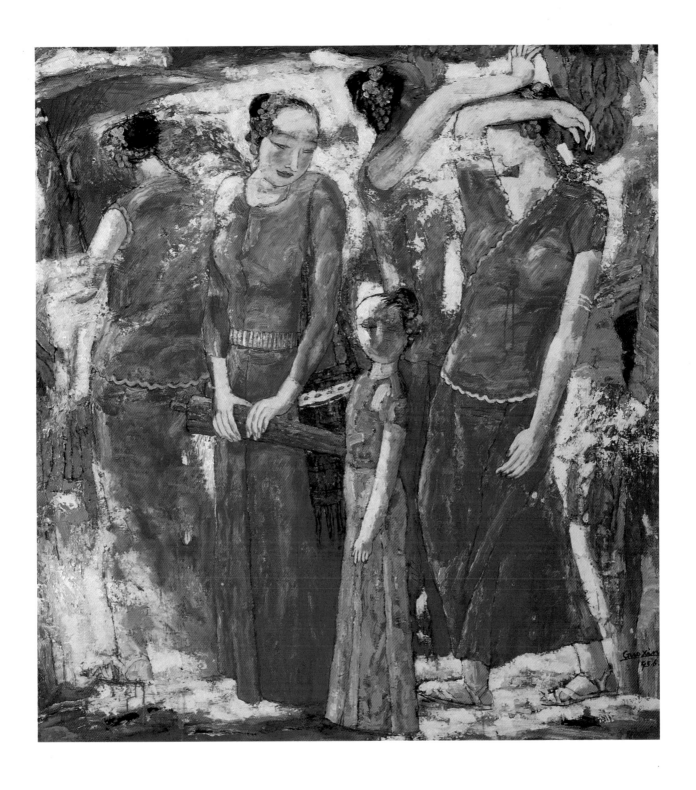

13. 杨国新《泼水节印象》 铜奖　Yang Gou-xin　IMPRESSION SPRINKING WATER FESTIVAL　Bronze Award

140X130CM

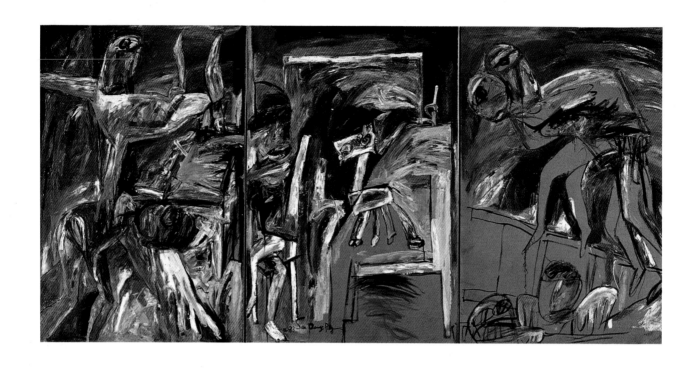

14. 苏东平《怀疑·嫉妒·厌倦－关注鲍依斯的人们》　铜奖　Su Dong-ping　DISTRUST·JEALOUS·TIRED-THE PEOPLE PAY MORE ATTENTION TO BOYES　BronzeAward　132X285CM

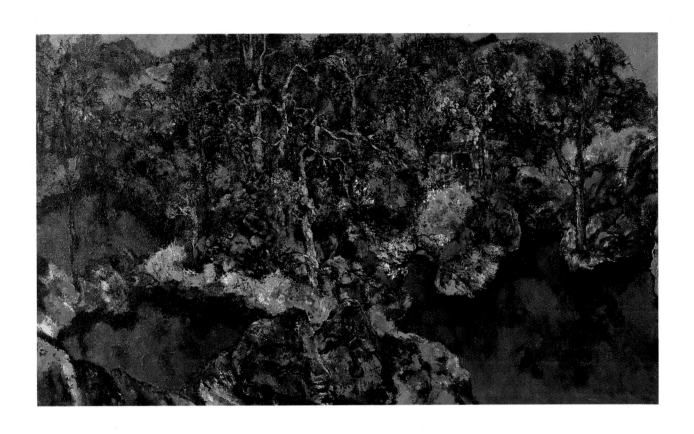

15. 洪凌《翠谷幽潭》 铜奖 Hong Ling DEEP AND SERENE BronzeAward 112x194CM

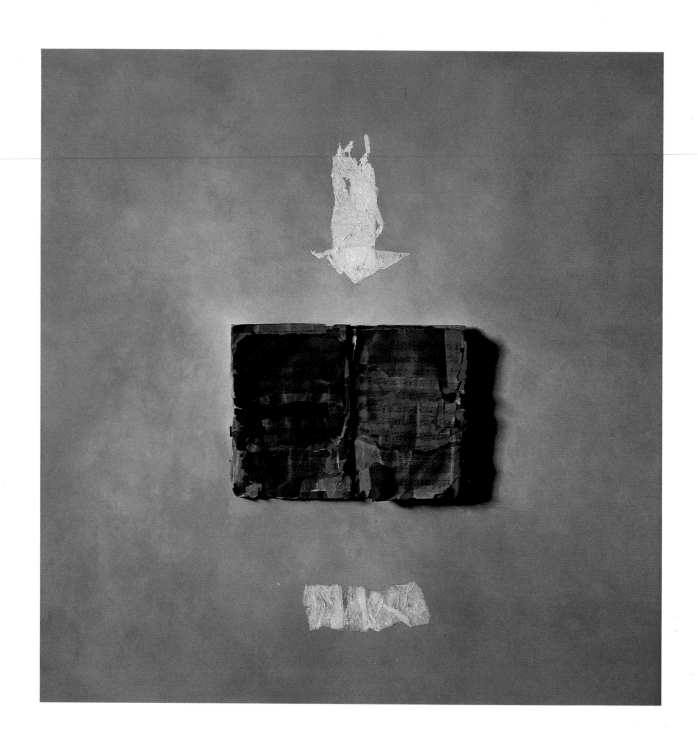

16. 刘国新 《抛物线》　铜奖　Liu Guo-xin　PARABOLA　BronzeAward

130X130CM

17. 李延洲《冷寂冬日》 铜奖　Li Yan-zhou　COLD WINTER　BronzeAward

175X161CM

18. 郭晋 《飘过的上帝之一》　铜奖　Guo-Jin　THE GOD FLOATED BY　BronzeAward　　　　146X115CM

19. 郭润文 《梦归故里》　铜奖　Guo Run-wen　DREAM OF RETURNING HOME　BronzeAward

116X121CM

20. 陈淑霞 《阳光留驻》　铜奖　　Chen Shu-xia　SUNSHINE　BronzeAward

140X120CM

21. 杨国幸《我们还需要什么？》　铜奖　Yan Guo-xin　WHAT DO WE NEED?　BronzeAward

153X173CM

22. 徐虹 《穿越四季》　佳作奖　Xv Hong　CROSS THE FOUR SEASONS　Excellent Award

23. 唐晖 《时期机器》  佳作奖  Tang Hui  TIME MACHINE  Excellent Award

220X110CM

24. 吴维佳《战士》　佳作奖　　Wu Wei-jia　SOILDERS　Excellent Award

180X300CM

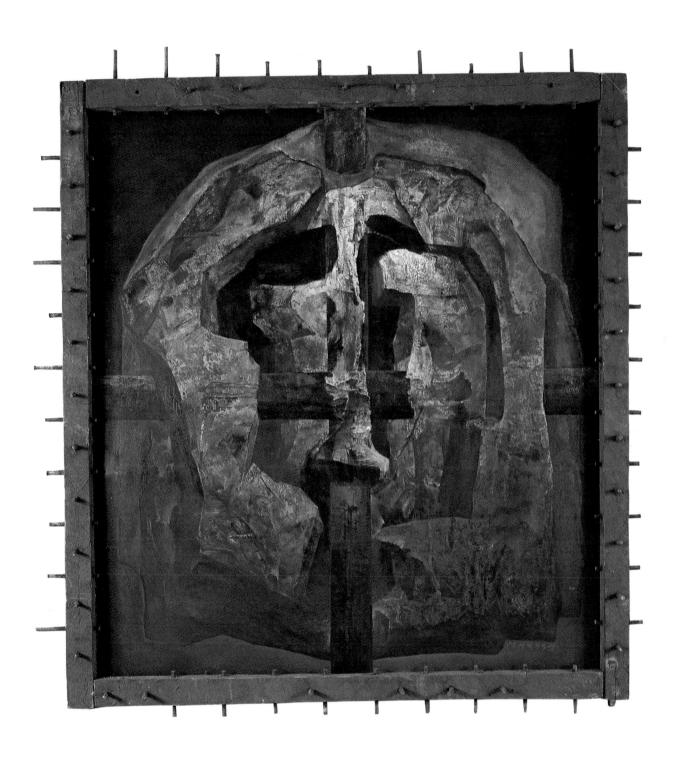

25. 莫鸿勋《封存一团快破碎的记忆》 佳作奖　Mo Hong-xun　SEAL OFF MEMORY OF MASS CRASHING　ExcellentAward　200X180CM

26. 于振立 《断念·小写三·搁置》　佳作奖　Yu Zhen-li　IDEA·THE THIRD·PUT ASIDE　ExcellentAward　　　194.9X199.5CM

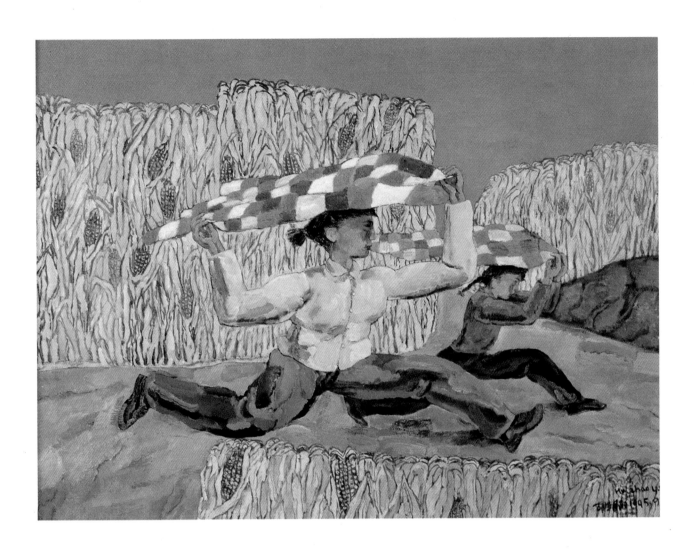

27. 胡朝阳 《阵雨》　佳作奖　Hu Chao-yang  SHOWER　ExcellentAward

118X158CM

28. 张国龙《黄土》　佳作奖　Zhang Guo-Long　THE YELLW LAND　ExcellentAward

210X195CM

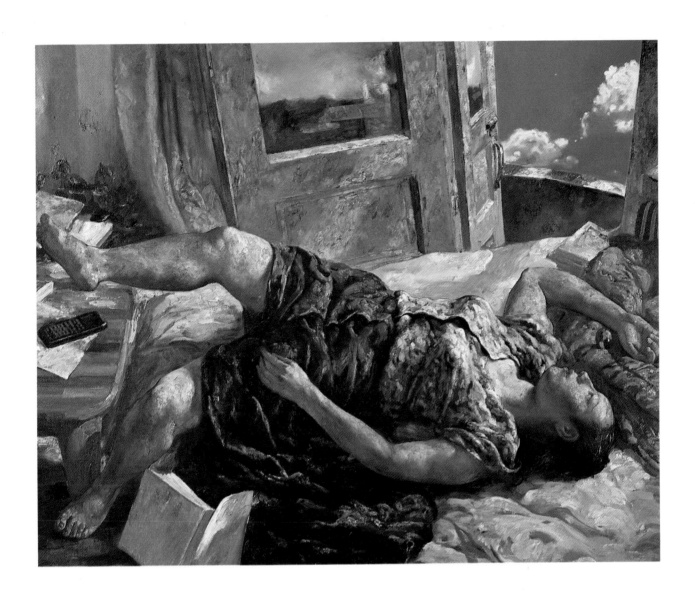

29. 秦秀杰 《云》 佳作奖 QinXiu-jie THE CLOUD ExcellentAward

130X162CM

30. 井士剑 《圆明园》　佳作奖　JingShi-jian　RORAL PALACE　ExcellentAward

140X160CM

31. 顾黎明 《门神－线板·色板 NO·18》　佳作奖　Gu Li-ming　DOOR GOD　ExcellentAward　　　　130X162CM

32. 贾鹃丽 《煌》　佳作奖　Jia Juan-li　BRILLIANT　ExcellentAward

160X160CM

33. 陈曦 《仿膳》　佳作奖　　Chen xi　CLASSICAL RESTAURANT　　ExcellentAward

165X180CM

34. 袁晓舫 《"战斗"－飞行计划》 佳作奖　Yuan Xiao-fang　BATTLE-FLYING PIAN　ExcellentAward

153X228CM

35. 郭正善 《静物》　佳作奖　　Guo Zhong-shan　STILL LIFE　　ExcellentAward　　　　　　　　　　90X116CM

36. 徐安民 《THE  WORK  S2-9 号》    佳作奖    Xu An-min   THE WORK S2-9LIFE     ExcellentAward

180X160CM

37. 王清丽《母亲湖》　佳作奖　Wang Qing-li  MOTHER LAKE　ExcellentAward　　160X120CM

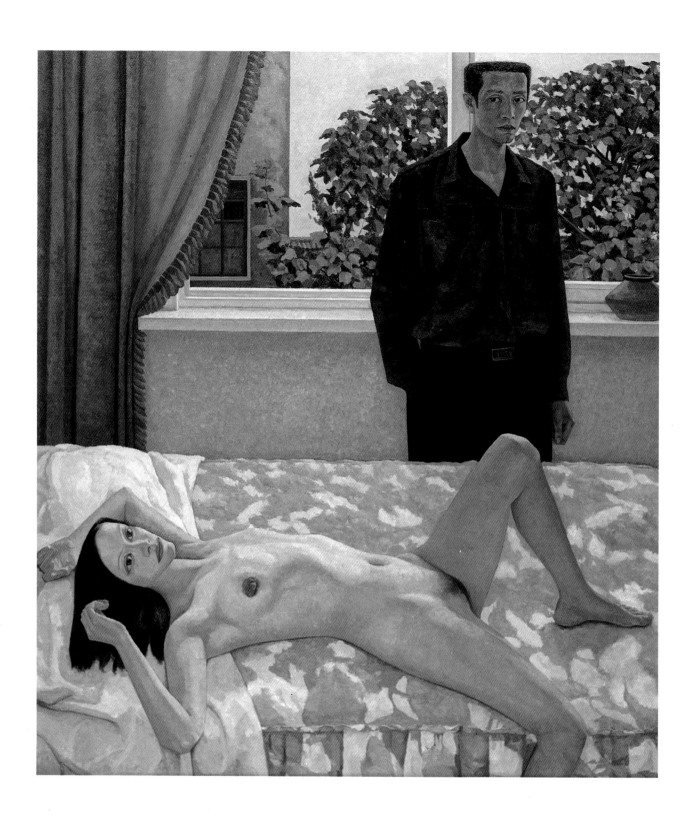

38. 陈海鹏《空间》　　Chen Hai-peng　SPACE

180X160CM

39. 赵竹《虹之后·勋布景·清灯》（三联）　　Zhao Zhu　AFTER THE RAINBOW·SCENERY·LIGHT LAMP　　<span>194X291CM</span>

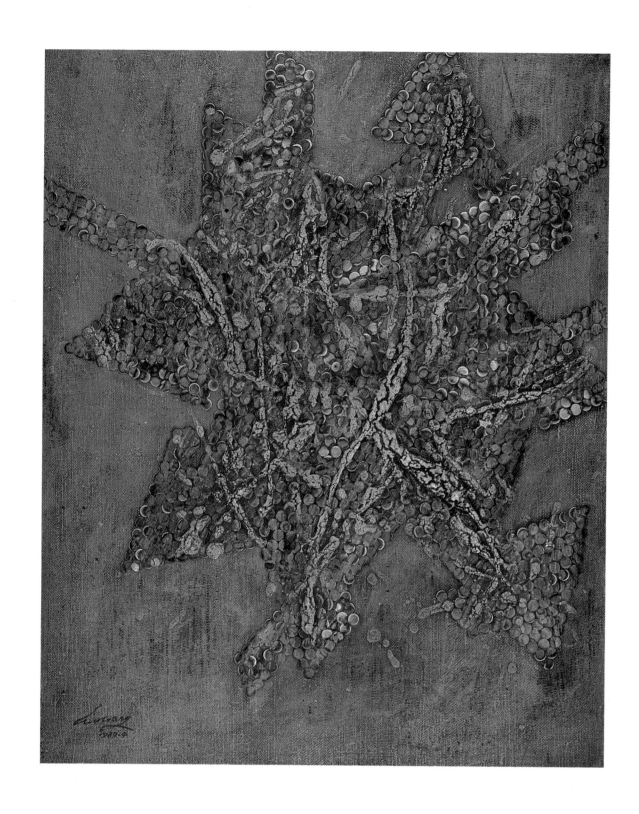

40 刘刚 《遗迹》　　Liu Gang　THE TRACE

73X59CM

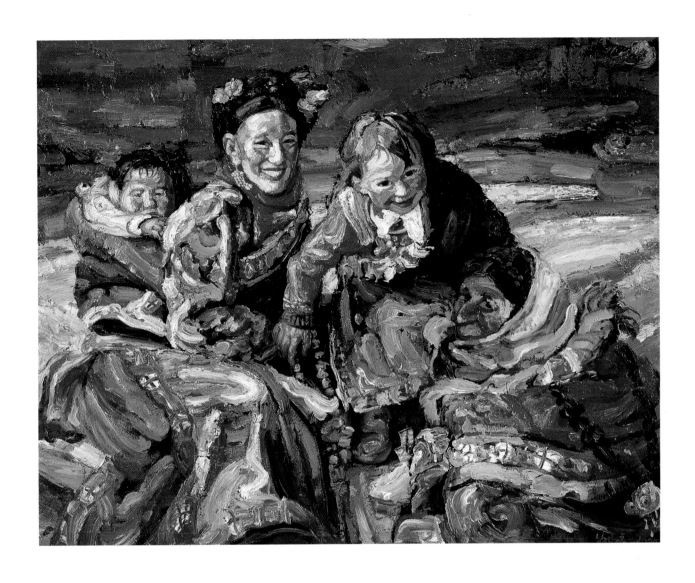

41. 姚永 《扎西得勒》　　Yao Yong　　ZHA XI DE LE

73X59CM

42. 宁方倩《湖中之鸟之六》　　Ning Fang Qian　　THE FASHION　　130X160CM

43. 谭涤夫 《深秋的山谷》　　Tan Di-fu　　DEEP AUTUMN　　　　　　　　　　　　　　182X154CM

44. 孙世伟 《仙人掌》　　Sun Shi-wei　　CACTUS

100X72.5CM

45. 庄威 《江南春晓》    Zhuang Wei    SPRING IN THE SOUTH                                           114X146CM

46. 谢建德 《西部风景－城市二》　　Xie Jian-de　WEST LANDSCAPE-CITY　　140X140CM

47. 韩大为 《红色气球》　　　Han Da-wei　　RED BALLON　　　　　　　　　　155X150CM

48. 燕杰《挤奶妇》　　Yan Jie　　MILKING WOMAN

140X150CM

49. 王克举 《农妇》　　Wang Ke-ju　　VILLAGE WOMAN

146X130CM

50. 赵宪辛 《北京·老外》　　Zhao Xian-xin　BEIJING FORENINERS

130X162CM

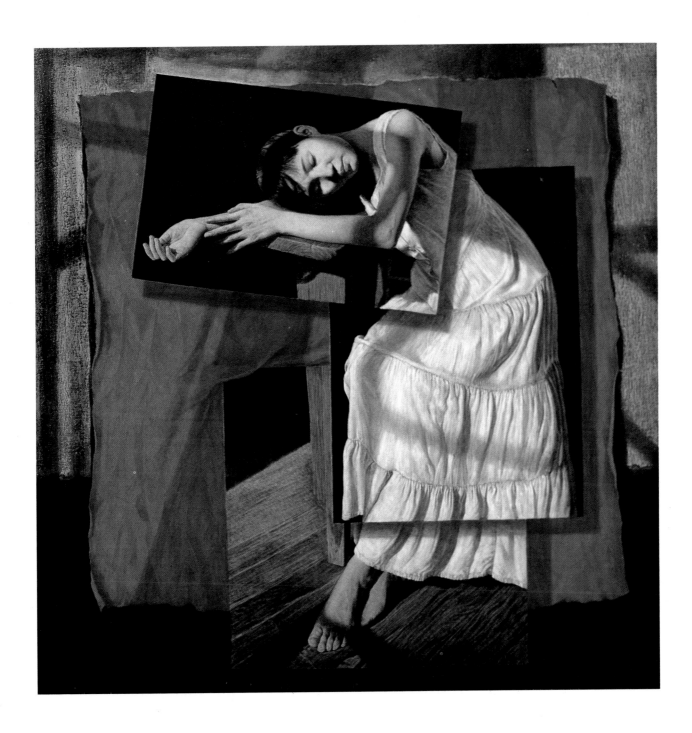

51. 张宏伟《投影》　　Zhang Hong-wei　　PROJECTION

130X130CM

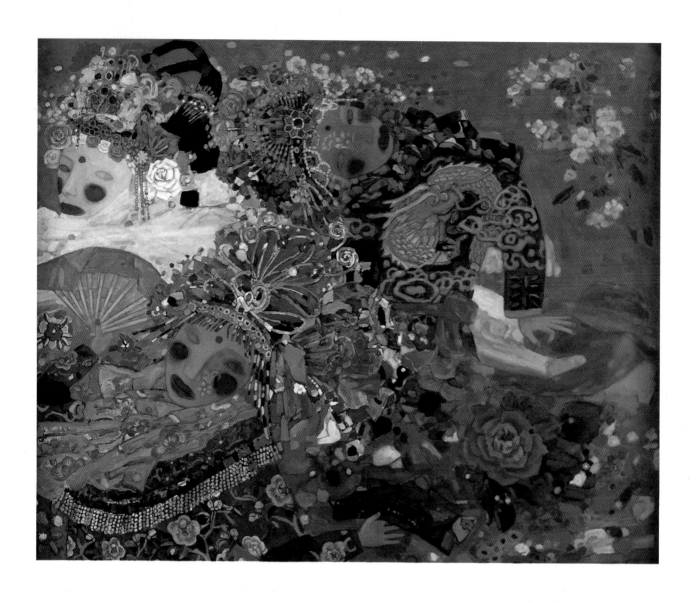

52. 王占武 《解放》　　　Wang Zhan-wu　　LIBRERATION

130X162CM

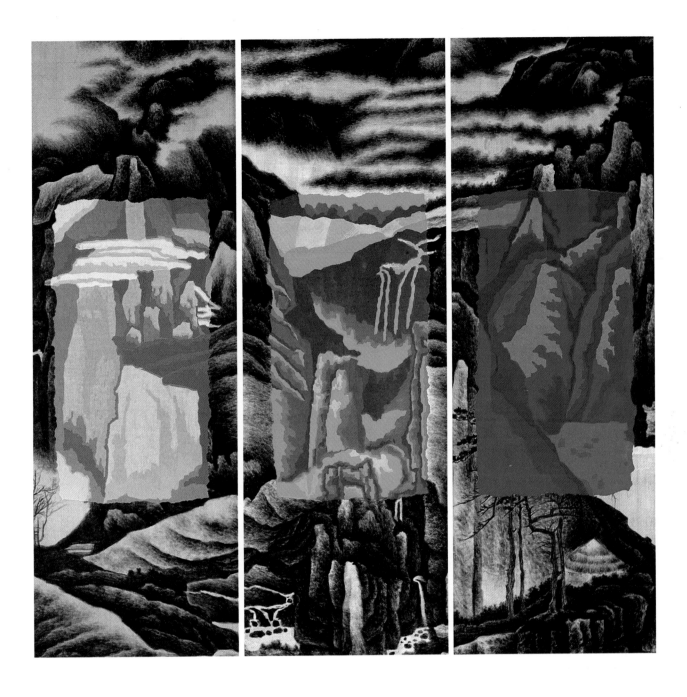

53. 马俊、赵琨 《重塑》　　Ma Jun,Zhao Kun　　CREATION AGAIN　　198X188CM

54. 许敏《秋实》　　Xu Min　　AUTUMN HARVEST

145X122CM

55. 叶恒贵 《空中大飞机》　　YeHeng-gui　BIG AIRPLANE IN THE AIR

170X150CM

56. 赵文华 《园地》　　Zhao Wen-hua　　GARDEN

120X140CM

57. 赵箭飞 《平仄系列之四》　　Zhao Jian-fei　　STRIGHT AND OBLIPUE SERIES NO.4　　　　　　100X110CM

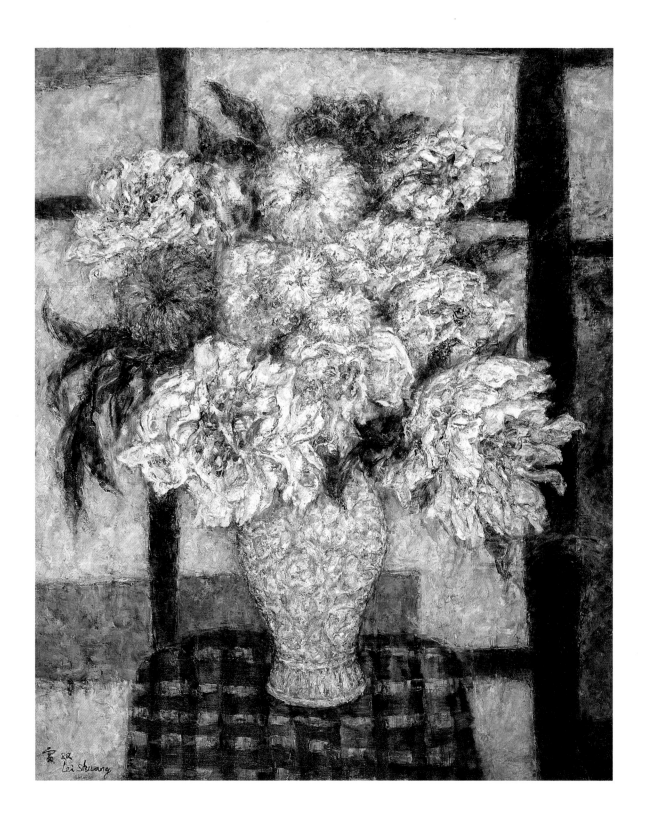

58. 雷双《白色花束》　　Lei Shuang　　WHITE FLOWERS　　　　　　　　　100X81CM

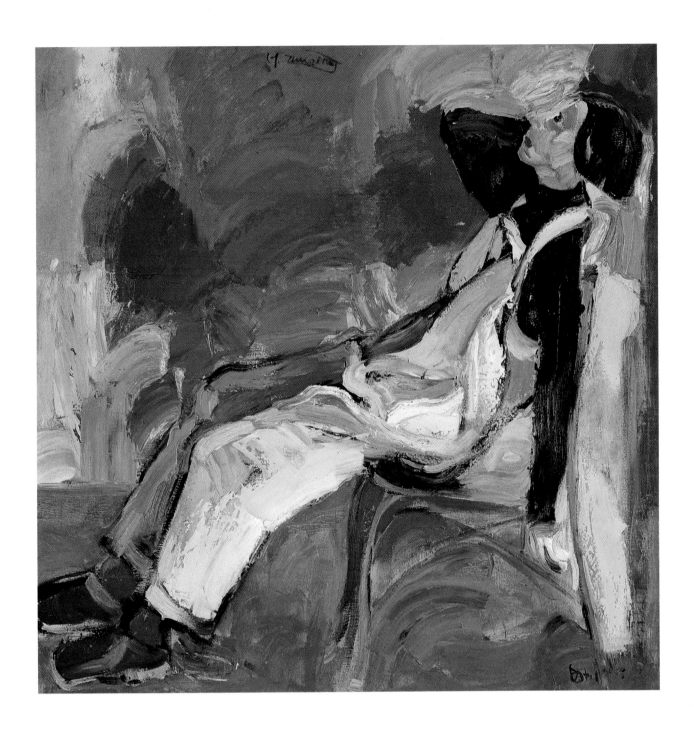

59. 胡骏荣 《斜靠着椅子的燕子》　　Hu Jun-rong　　YAN ZI SITS IN CHAIR　　　　　　　　　　120x120CM

60. 朱新建《生涯》　　Zhu Xin-jian　CAREER

80X80CM

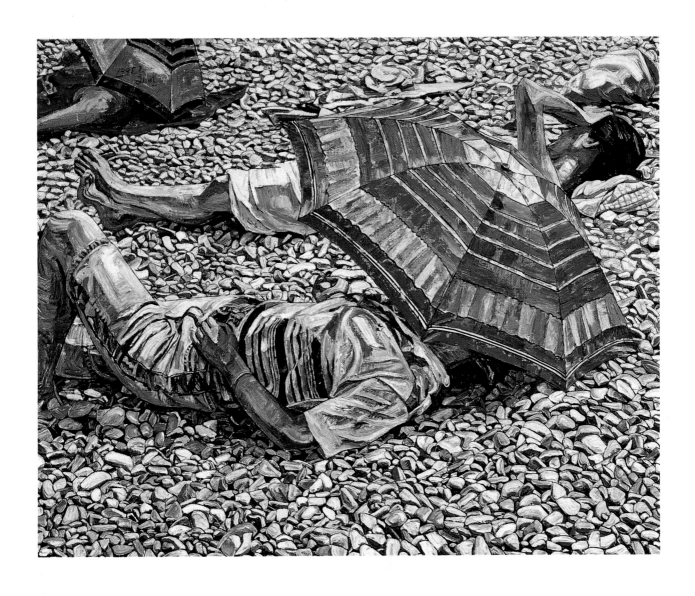

61. 刘明 《'94 夏日海滩第三回》　　Liu Ming　　THE THIRD ON THE SUMMER SEABEACH IN 1994　　130X162CM

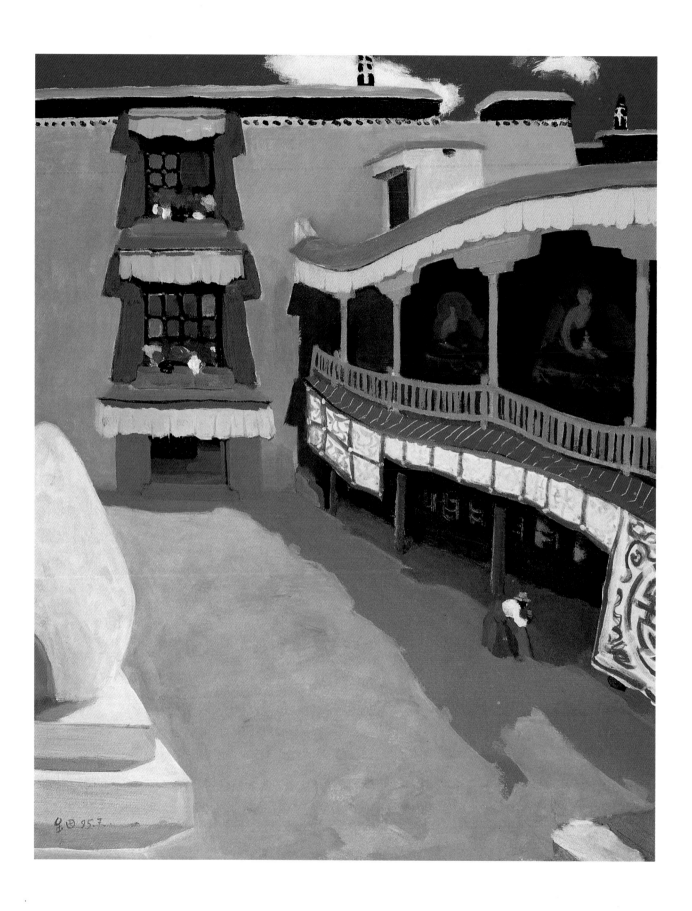

62. **金田**《净》　　Jin Tian　SILENCE

81X65CM

63. 丁方《东方之路》　　Ding Fang　　ROAD TO THE EAST　　　　　　　　65X100CM

64. 梁彪《家》　　Liang Biao　　THE HOME

185X165CM

65. 陆成刚 《拾穗》　　Lu Cheng-gang　　GLEAN WHEAT

80X100CM

66. 陈卫闽 《风迎》    Chen wei-min    THE WIND

97X130CM

67. **李毅松 《工业脊梁》**　　Li Yi-song　INDUSTY BACK

120X180CM

68. 毛岱宗《山村冬市》　　Mao Dai-zong　　WINTER MARKET IN THE MOUNTAIN VILLAGE

110X140CM

69. 任建成《童年梦系列之一——游行》　Ren Jian-cheng　ONE OF CHILD'S DREAMS----PARADEVILLAGE　130X195CM

70. 王利丰《"真"系列组画》　　Wang Li-feng　　THE REAL　　　　　　　　　　　　　　　120X92CM

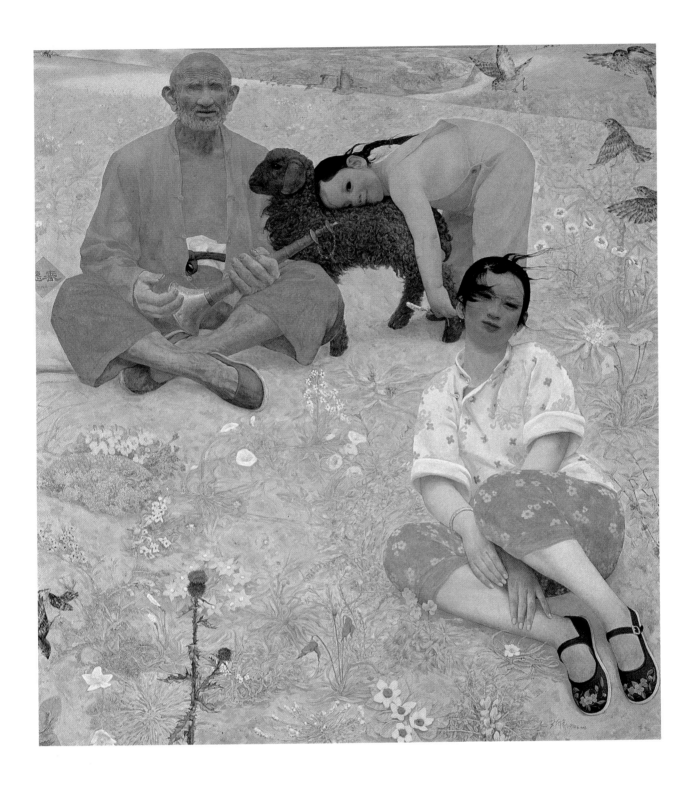

71. 王沂光 《听春》　　　Wang Yi-guang　　　HEAR THE SOUND FROM SPRING

158X148CM

72. **曹吉冈**《秋山野意》　　Cao Ji-gang　　AUTUMN MOUNTAINS

200x175CM

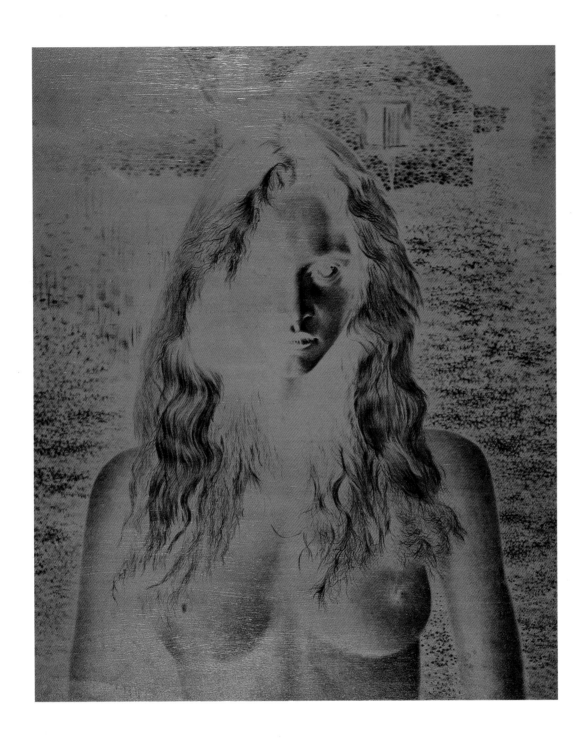

73. 任戬《人体档案之三 "亚丽安娜－X底片"》    Ren Jian    THE THIRD OF HUMAN BODY'S FILE"ALYANAN----X PHOTOGRAPHIC PLATE"    100X72.5CM

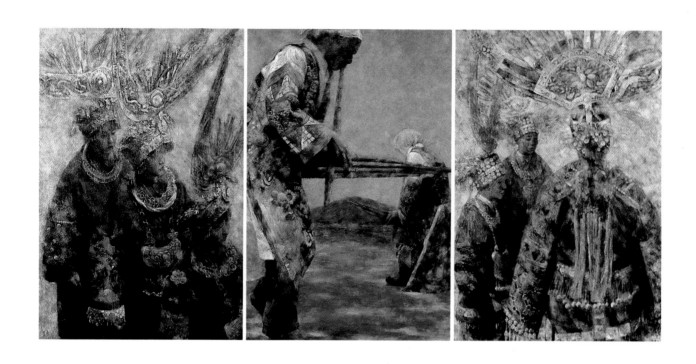

74. **翟勇** 《苗年－系列组画之一》　　Zhai Yong　　THE FESTIVAL OF MIAO NATIONALITY　　　　145X310CM

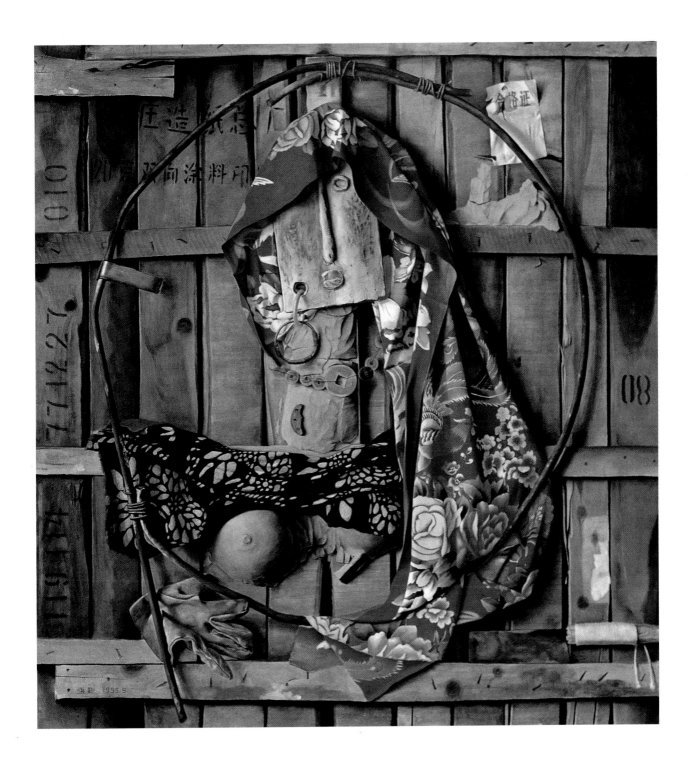

75. 张澎 《联作之一，小凤儿，今年整十八》　　Zhang Peng　　IN 1995,XIZO FENG--IS EXACITLY 18 YEARS OLD　　120X113CM

121

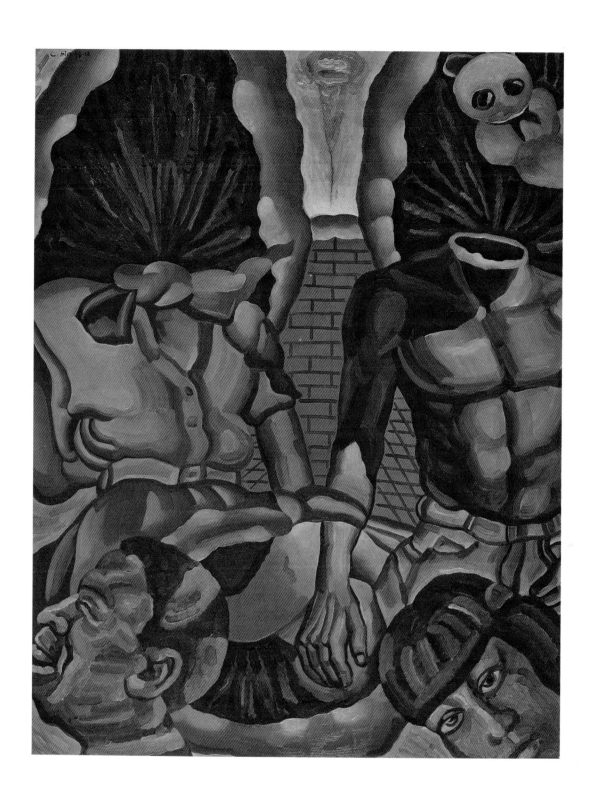

76. 王朝斌 《自语》　　　Wang Chao-bin　　TALK TO ONESELF

115X90CM

77. 张晖 《傍晚》　　Zhang Hui　　AT DUSK

65X240CM

78. 俸正杰《皮肤的叙述·红双喜》　　Feng Zheng-jie　　SKIN'S NARRATION-DOUBLE HAPPINESS　　150X265CM

79. 韦博文《陶乐·地声·天谷》　　Wei Bo-wen　　POTTER·EARTHQUAKS SOUNDS·HEVEN　　100X320CM

80. 舒群 《同一性语态：一种后先锋主义？》　　Shu Qun　　LDENTITY VOICE--ONE KIND OF POSTVANGUARDISM?　　170X135CM

81. 林菁菁 《风景断章》（三联）　　LinJing-jing　　PART OF LANDSCAPE　　140X180CM

82. 张永旭 《小夜曲》　　Zhang Yong-xu　SERENADE　　　　　　　　　　130X180CM

83. 韩雄 《合影 1995》    Han Xiong    GROUP PHOTO IN 1995    155X155CM

84. 康笑雨 《太阳雨》　　Kang Xiao-yv　SUNRAIAN　　　　　　　　　　110X125CM

85. 刘剑《95·面孔》　　Liu Jian　　1995•FACE

179X153CM

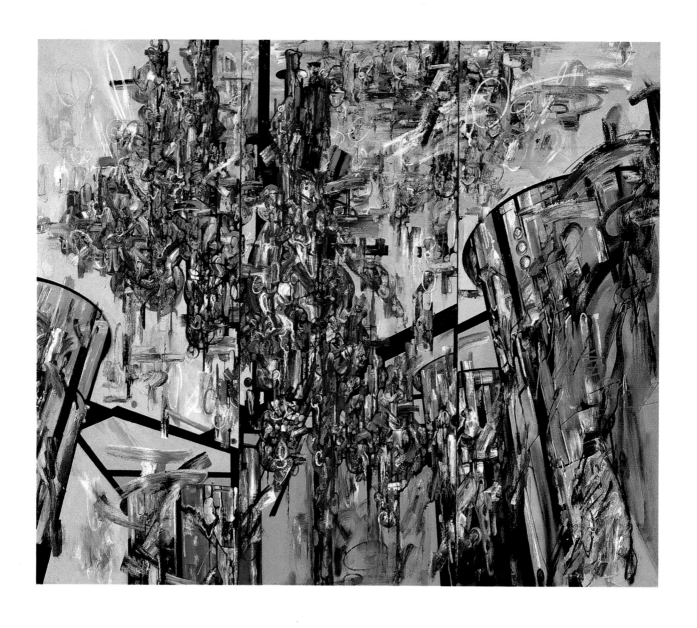

86. 江海《都市结构》    Jiang Hai    CITY'S CONSTRUCTION

190X225CM

87. 董文胜《成人游戏·2号》    DongWen-sheng    ADUIT'S GAME ·NO.2    81X225CM

88. 张延刚 《妆》　　Zhang Yan-gang　DRESSING　　　　　　　　　　　　　80X100CM

89. 何森《手的图象》　　He Sen　　IIIUSTRATION OF HANDS

180X200CM

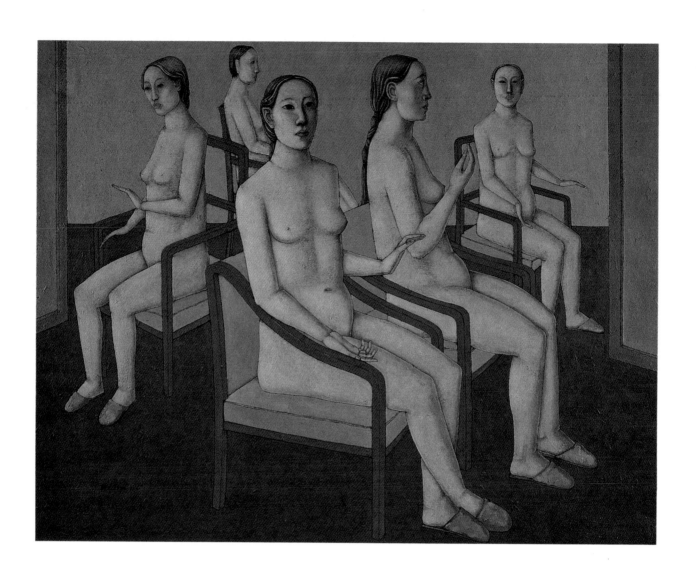

90. 韩冬《檀香木的室内》　　Han Dong　SANDALWOOD　　160X210CM

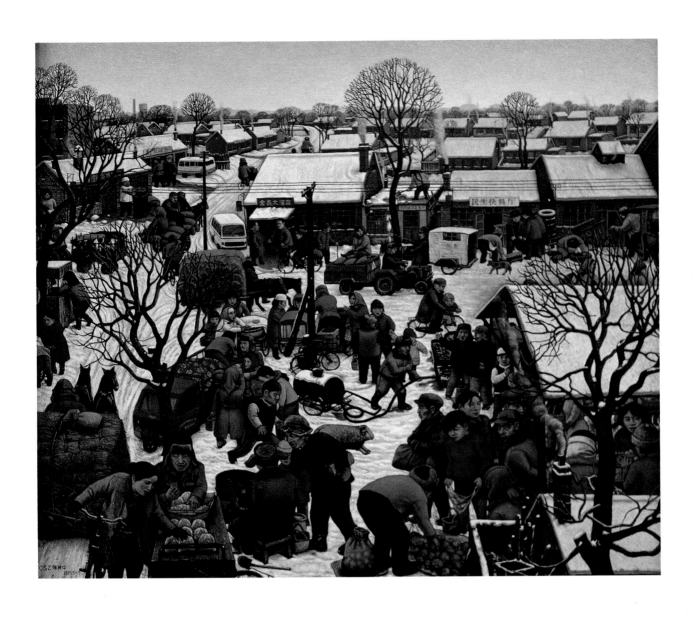

91. 陈树中《野草滩镇十字口》　　Chen Shu-zhong　　THE CRIOSSING YE CAO TAN COUNTY　　130X160CM

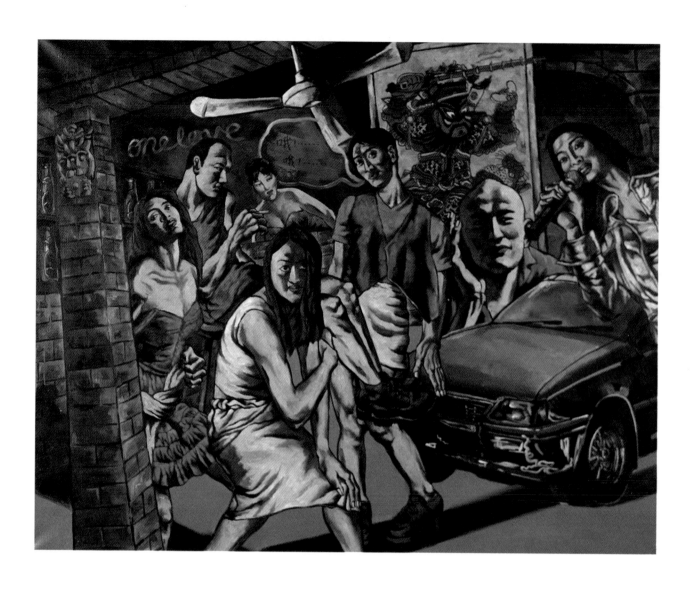

92. **李邦耀**《我们》　　Li bang-yao　　WE

150X190CM

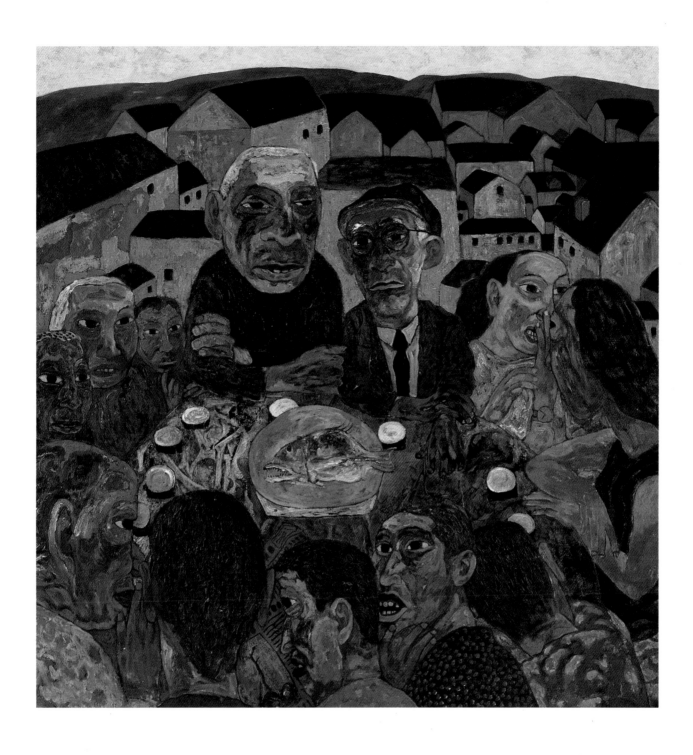

93. 朱进《晚宴》　Zhu Jin　DINNER　　　　　　　　　　180X180CM

94. 吕鸿、张昕 《九十年代大工业－鞍山钢铁公司系列之一》（三联）　Lv Hong.Zhan XinJin　90'INDUSTRY--ANSHAN STEAL CO. SERIES PAINTING　190X414CM

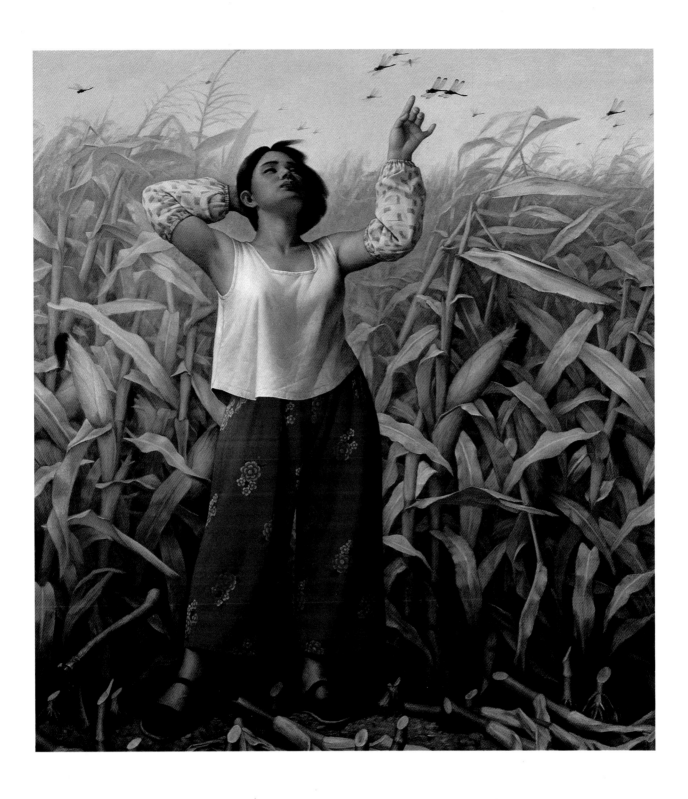

95. 王云鹏 《秋日印象》　　Wang Yun-peng　IMPRESSING OF AUTUMN

177X167CM

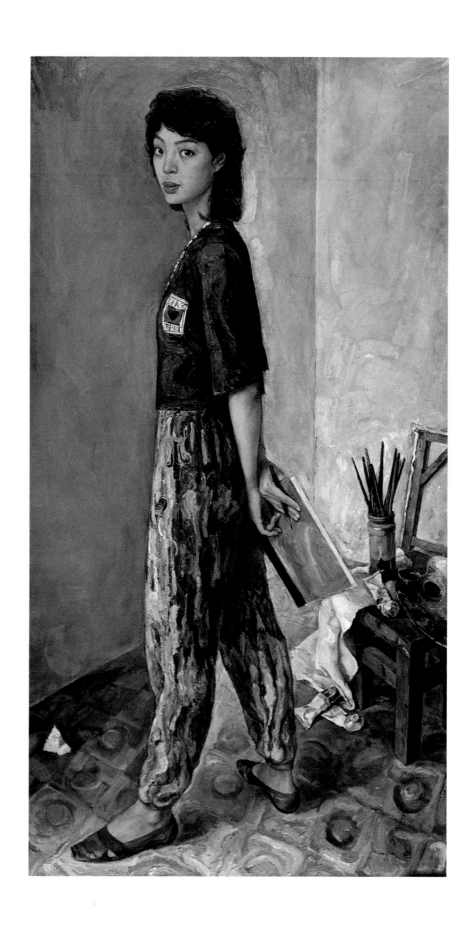

96. 袁文彬《灵子》　　Yuan Wen-bin　LING ZI

190X100CM

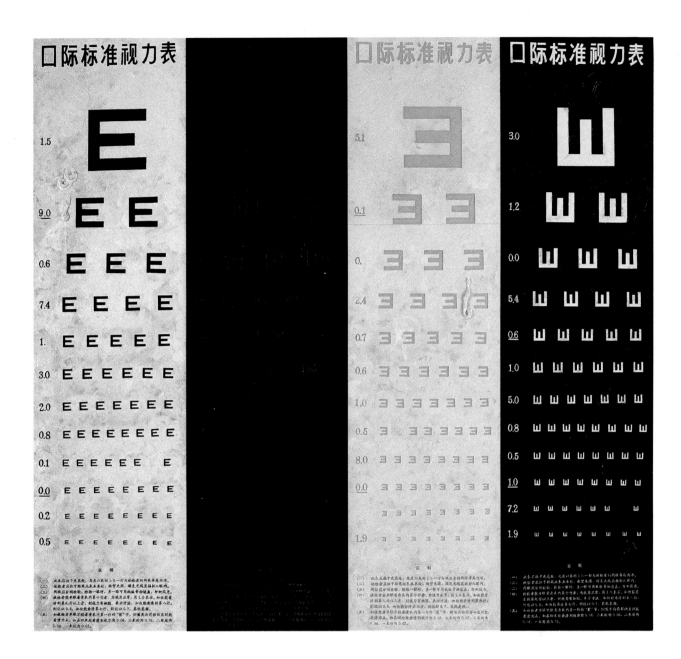

97. 陈少峰《国际标准》　Chen Shao-feng　INTENATIONAL STANDARD　192X208CM

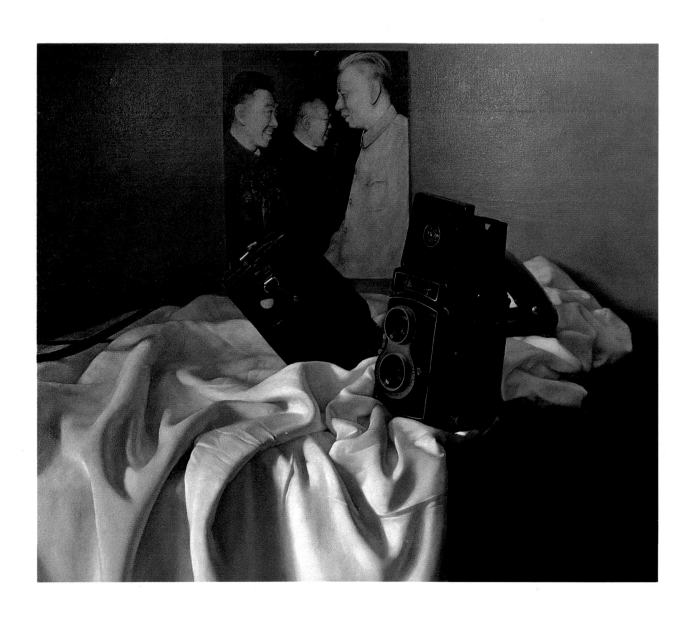

98. 王卫东 《永存的记忆》　　Wang Wei-dong　　MEMORY FOREVER　　　　　　53X65CM

99. 蔡锦 《美人焦 66》　　Cai Jin　　CANNA NO.66　　　　　　　　　　　　　190X150CM

100. 王玉平 《鸟·人》　　　Wang Yu-ping　　BIRD·HUMAN　　　　　　　　　　　　　190X220CM

101. 夏小万 《跌落》　　Xia Xiao-wan　　THE FALL

162X130CM

147

102. 白明 《物语》　　Bai Ming　　NATURAL LANGUAGE　　　　　　　190X110CM

103. 张志坚《情思》    Zhang Zhi-jian    AFFECTION

80X100CM

104. 曲欣 《自行车》    Qu Xin    BICYCLE

115X88CM

105. 陈绿寿《山庄的喜悦》　　Chen Lv-shou　　JOYOUS OF MOUNTAIN-VILLAGE　　140X170CM

106. 傅剑锋 《脉－系列组图》　　Fu Jian-feng　　ARTERIES AND VEINS

110X130CM

107. 段江华 《天门》　　Duan Jian-hua　　DOOR OF HEVEN

187X136CM

108. 段正渠《黄河船夫》　　Duan Zheng-qv　　BOATMAN IN THE YELLOW RIVER

125X106CM

109. 段建伟《少年》　　Duan Jian-wei　　EARLY YOUTH

125X110CM

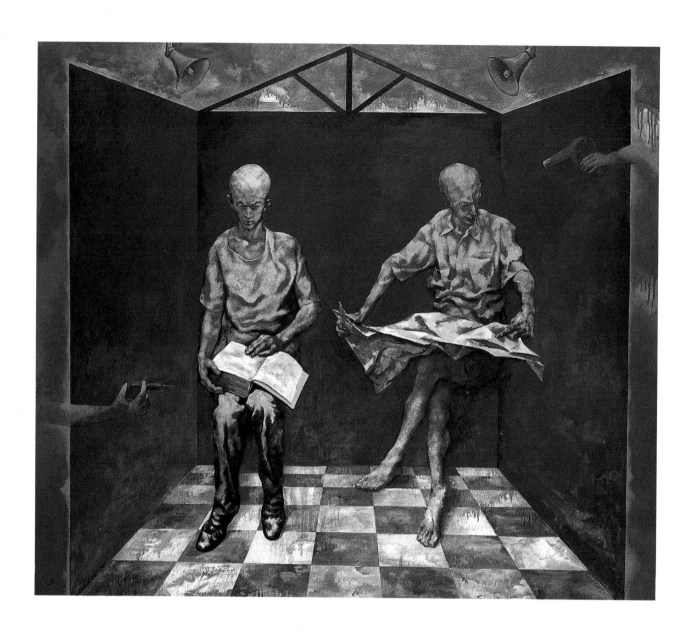

110. 石磊 《论感知》    Shi Lei    ON PERCEPTION

180X180CM

111. 张洪波《二十一世纪雅尔塔会议》　　Zhang Hong-bo　　THE MEETING OF 21TH CENTUNRY IN YALTA　　160X360CM

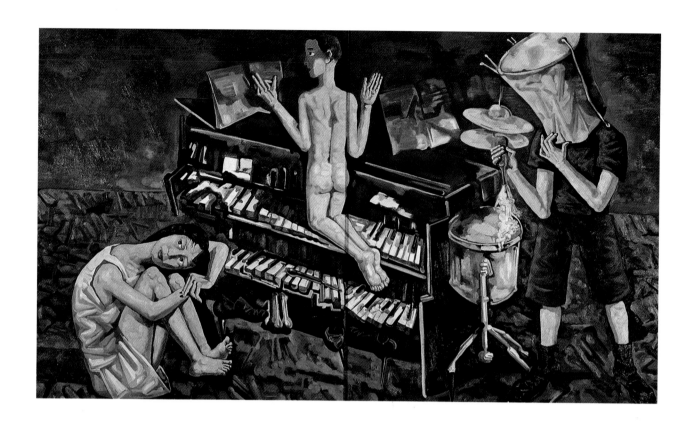

112. 任思鸿《记 '94 夏为一个女孩的生日》    Ron Si-hong    FOR A GIRL'S BIRTHDAY IN THE SUMMER IN 1994    150X340CM

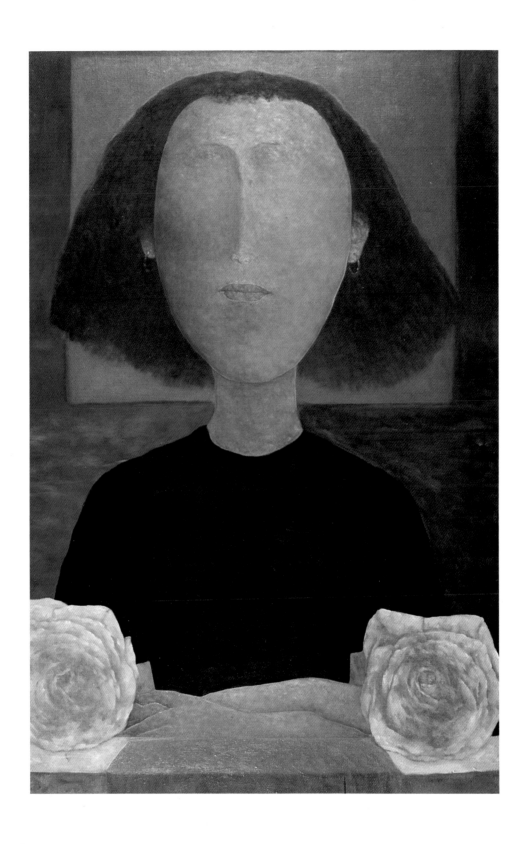

113. 廖邦明《褪色红布－新偶像》　　Liao Bang-ming　　THE RED CLOTHING IS FADING---NEW LODOL　　170X110CM

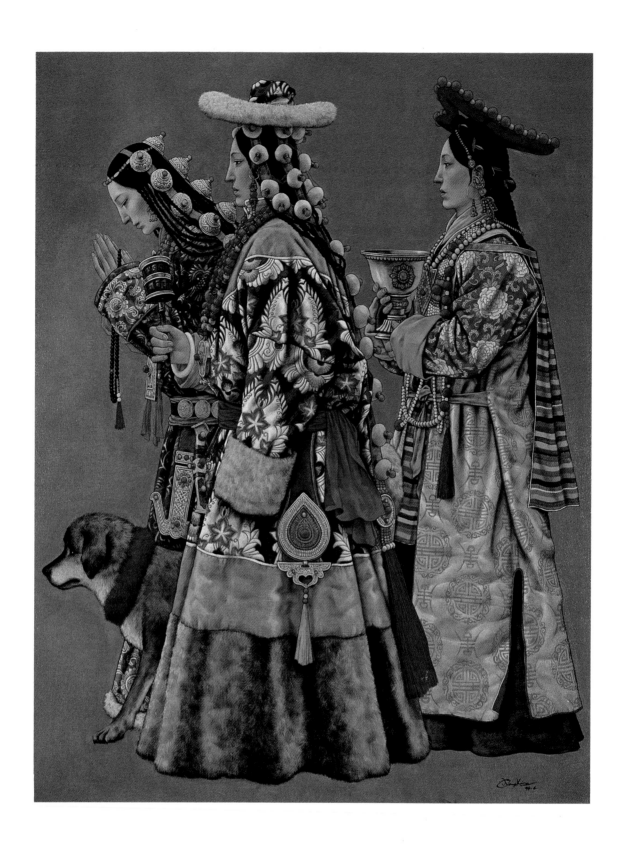

114. **谢恒星** 《康巴女》    Xie Heng-xing    KANG BA GIRLS

100X81CM

# 第三届中国油画年展参展作者简介

**白 明**
Bai Ming

1965年生，1994年毕业于中央工艺美术学院陶瓷系。1993年参加博雅油画大赛并获奖，1993年参加首届中国油画双年展，同年获平山郁夫艺术奖金，1994年参加《江苏画刊》纪念展。

**曹吉冈**
Cai Ji-gang

1955年生，1984年毕业于中央美术学院。曾参加第七届全国美展，第一届中国油画展，第二届中国油画年展及第八届全国美展。1994年作品《深谷浅溪》参加新铸联杯油画精品展，并获银奖。

**蔡 锦**
Cai Jin

女，1986年毕业于安徽师范大学美术系，后进中央美术学院油画进修班学习。曾参加第一届中国油画展，第一届中国油画年展，1994年美术批评家年度提名展。1995年赴瑞典参加中国现代艺术展。

**陈海鹏**
Chen Hai-peng

1963年生，1985年毕业于山东艺术学院美术系，作品曾多次入选各级美展。

**陈绿寿**
Chen Lu-shou

1955年生，1982年毕业于中央工艺美术学院。1985年作品《兆丰年》参加国际青年美展，1992年作品《被覆盖的脊梁》参加广州首届90年代艺术双年展获提名奖，同年参加当代艺术文献展，1994年作品《巴楚风》参加第八届全国美展获优秀奖。

**陈少峰**
Chen Shao-feng

1961年生，1991年毕业于中央美术学院民间美术系研修班，现为北京职业画家。

**陈淑霞**
Chen Shu-xia

女，1987年毕业于中央美术学院。曾获第一届中国油画年展银奖，作品曾入选中国油画展和第二届中国油画年展，1995年分别在中央美术学院画廊和深圳美术馆举办个展。

**陈树中**
Chen Shu-zhong

1960年生，1984年毕业于鲁迅美术学院。1991年作品《山村》参加第一届中国油画年展，1993年作品《野草滩的集市》入选中国油画双年展，《野草滩的冬天》入选第二届中国油画年展，1994年《我爱这生机勃勃的野草滩》入选第八届全国美展。

**陈 曦**
Chen Xi

女，1991年毕业于中央美术学院油画系四画室。1993年作品《大亨酒家》入选首届中国油画双年展，获学术奖，1995年两幅作品参加德国当代国际艺术展。

**陈卫闽**
Chen Wei-min

1959年生，毕业于四川美院油画系。1991年参加北京西三环艺术研究文献展，1993年参加第二届中国油画年展，同年参加中国油画双年展获提名奖，1994年参加第二届中国油画展。

**邓箭今**
Deng Jian-jin

1961年生，1986年毕业于江西景德镇陶瓷学院雕塑系。曾参加第七届全国美展，第二回中国当代艺术文献资料展，第二届中国油画展，作品《作个快乐人》获中国油画双年展学院奖。1995年参加中国油画家代表团赴美考察，展览。

**丁 方**
Ding Fang

1956年生，1982年毕业于南京艺术学院美术系，1986年毕业于南京艺术学院美术系油画专业，获硕士学位。现为职业画家，曾多次参加国内外重要美展并获奖，出版有《丁方画集》、《丁方》等。

**董文胜**
Dong Wen-sheng

1970年生，1991年毕业于常州技术师范学院工艺美术系，多次参加全国各类美展。

**段建伟**
Duan Jian-wei

1961年生，1981年毕业于河南大学美术系。作品曾参加首届中国油画年展，第二届中国油画展，第八届全国美展和在香港大学博物馆展出的当代中国油画展。1991年在中央美院画廊与段正渠举办联展。

**段江华**
Duan Jiang-hua

１９６３年生，１９８９年毕业于中央美术学院油画系三画室。１９９３年作品《王·后·2 号》获第二届中国油画展油画艺术奖。１９９４年作品《捆扎的王和后》入选第八届全国美展获优秀作品奖，１９９５年随中国美术家代表团出访日本并做学术交流。

**段正渠**
Duan Zheng-qu

１９５８年生，１９８３年毕业于广州美术学院油画系。作品《山歌》参加第一届中国油画展并赴日本展出，《走西口》获第一届中国油画年展优秀奖，《北方》参加第二届中国油画展，《黄河船夫》被评为第八届全国美展优秀作品，１９９１年在北京中央美院画廊举办《段正渠段建伟油画展》。

**俸正杰**
Feng Zheng-jie

１９６８年生，１９９５年毕业于四川美术学院，获硕士学位。１９９２年参加第二回中国当代艺术文献资料展，１９９４年参加第二届中国油画展（北京）、同年参加中港台大专美术作品展（香港）。

**傅剑锋**
Fu Jian-feng

１９６１年生，毕业于四川美院油画系。曾参加中国油画双年展，中国油画年展，第二届中国油画展等，并有多幅作品赴海外展出并被收藏。

**宫立龙**
Gong Li-long

１９５３年生。１９８０年油画《路》参加第二届全国青年美展获三等奖，１９８７年油画《丑角》参加第一届中国油画展，１９８９年油画《坐福》参加第七届全国美展，１９９２年作品《腊月二十九》参加广州９０年代艺术双年展，１９９３年作品《新潮》参加第二届中国油画展，１９９４年作品《打台球》参加第八届全国美展并获奖，参加１９９４年美术批评家年度提名展。

**顾黎明**
Gu Li-ming

１９６３年生，１９８５年毕业于山东曲阜师范大学美术系，１９８７年入中央美术学院油画系助教班。１９８９年参加中国现代艺术展，１９９３年参加中国油画双年展并获学术奖，同年１０月参加第二届中国油画年展，１９９４年参加第八届全国美展并获 大奖。

**郭 晋**
Guo Jin

１９６４年生，１９９０年毕业于四川美术学院油画系。１９９２年参加广州首届９０年代艺术双年展，１９９４年参加重庆'９４陌生情境展。

**郭润文**
Guo Run-wen

１９５５年生，１９８２年毕业于上海戏剧学院舞台美术系，１９８８年结业于中央美院油画助教进修班。曾多次参加全国美展，其中作品《痕迹》获中国油画双年展学术奖，作品《永远的记忆》获第二届中国油画展艺术奖，１９９５年参加中国油画家代表团赴美考察并举办展览。

**郭正善**
Guo Zheng-shan

１９５４年生。１９８７年参加首届中国油画展，１９９２年参加广州90年代艺术双年展，获提名奖，１９９３年参加中国油画年展，同年参加中国油画双年展，获学院奖，１９９４年参加第二届中国油画展并获奖，同年参加第八届全国美展。

**韩大为**
Han Da-wei

１９６１年生，１９８７年毕业于鲁迅美术学院。１９９２年参加广州首届９０年代艺术双年展，获提名奖，１９９４年参加第二届中国油画年展和第八届全国美展。

**韩 冬**
Han Dong

１９５８年生，１９８６年毕业于南京艺术学院工艺系。１９９２年作品《室内－－人物》参加广州首届９０年代艺术双年展并获三等获。

**韩 雄**
Han Xiong

１９６５年生，１９９３年毕业于湖北美术学院师范系油画专业，作品《合影１９９４》入选第八届全国美展。

**何 森**
He Sen

１９６８年生，１９８９年毕业于四川美术学院。１９９１年参加第一届中国油画年展，１９９２年参加广州首届９０年代艺术双年展并获提名奖，１９９３年参加香港后'８９中国新

艺术展，中国油画双年展和第二届中国油画年展。

**洪　凌**
Hong Ling

１９５５年生，１９７９年毕业于北京师范学院美术系，１９８７年毕业于中央美术学院油画研修班。１９９１年参加第一届中国油画年展并获优秀奖，１９９３年作品《山水精神》参加第二届中国油画年展获铜奖，１９９４年参加第二届中国油画展。

**胡朝阳**
Hu Chao-yang

１９５９年生，１９８３年毕业于湖北艺术学院美术系，作品多次参加全国大展。

**胡骏荣**
Hu Jun-rong

１９６９年生，１９９２年毕业于浙江美术学院国画系，作品曾多次参加国内各级展览。

**贾鹃丽**
Jia Juan-li

女，１９８６年毕业于四川美术学院油画系，１９９１年毕业于中央美术学院油画系创作研究班。作品《秋瑾》入选上海首届中国油画展，《棋女》入选第七届全国美展，１９９１年作品《无言歌》入选第一届中国油画年展并获铜奖，同年，在中央美院画廊举办个展，数幅作品被海外收藏。

**江　海**
Jiang Hai

１９６１年生，１９８６年毕业于天津美术学院绘画系。１９８９年参加在中国美术馆举办的中国现代艺术展，１９９２年参加广州90年代艺术双年展获提名奖，１９９３年参加北京中国油画双年展获提名奖，１９９３年参加第二届中国油画年展，１９９４年参加第二届中国油画展。

**井士剑**
Jing Shi-jian

１９６０年生，作品曾参加第六届，第七届和第八届全国美展，并获第八届全国美展优秀作品奖。

**金　田**
Jin Tian

１９６０年生，１９８７年毕业于南京艺术学院美术系油画专业，作品多次入选国内各级美展。

**康笑宇**
Kang Xiao-yu

１９５６年生，１９８２年毕业于西安美术学院油画系，１９９３年作品《站立着的人体》参加北京中国油画双年展,并有多幅作品入选国内外专题性展览。

**雷　双**
Lei Shuang

女，１９９１年毕业于中央美院油画创作研修班。１９９１年作品入选首届中国油画年展，１９９３年入选第二届中国油画年展，１９９４年入选第二届中国油画展，同年参加第八届全国美展。

**冷　军**
Leng Jun

１９６２年生，１９８４年毕业于武汉师范大学艺术系。作品《马灯的故事》获全国美展铜奖，１９９２年参加广州90年代艺术双年展获优秀奖，１９９３年作品《网---关于网的设计》参加第二届中国油画年展并获银奖，作品多次参加展览并获奖。

**梁　彪**
Liang Biao

１９６３年生，１９８９年毕业于哈尔滨师范大学艺术学院，１９９４年入中央美院助教班进修深造。

**廖邦明**
Liao Bang-ming

１９６７年生，１９９２年毕业于四川美术学院版画系，现为职业画家，多幅作品被国外收藏。

**李邦耀**
Li Bang-yao

１９５４年生，１９７８年毕业于湖北艺术学院美术系。１９８９年作品《野草》入选中国现代艺术展，１９９２年作品《产品托拉斯》入选广州首届90年代艺术双年展获优秀奖。

**林菁菁**
Lin Jing-jing

女，１９９２年毕业于福建师范大学美术系，１９９４年至１９９５年在中央美院进修。

刘　刚
Liu Gang

１９６５年生，１９９１年毕业于中央美术学院油画系四画室。１９８９年作品《痕迹》入选第七届全国美展，１９９１年作品《同一流向》参加法国秋季沙龙展，作品《二个不同方向》参加第一届中国油画年展，１９９３年作品《平列的金属》参加中国油画双年展并获金奖。

刘大明
Liu Da-ming

１９６１年生，１９８６年毕业于吉林艺术学院美术系油画专业。１９８９年作品《间歇》获第七届全国美展铜奖，１９９３年作品《围墙－－清廷人物》参加首届中国油画双年展，１９９４年作品《清廷人物－－笼中鸟》参加第二届中国油画年展，作品《花絮－清廷 》参加第八届全国美展。

刘国新
Liu Guo-xin

１９６６年生，多幅作品被海外收藏家收藏。

刘　剑
Liu Jian

１９５８年生，毕业于北京师范学院美术系油画专业，１９８８年结业于湖北美术学院助教班。１９９４年作品《葵花地》入选第二届中国油画展，作品《面具》入选第八届全国美展。

刘丽萍
Liu Li-ping

女，１９８７年毕业于中央美术学院版画系。１９９３年获首届中国油画双年展学院奖，作品多次参加女画家专题展览。

刘　明
Liu Ming

１９５７年生。１９８９年参加第七届全国美展获银获，１９９１年参加首届中国油画年展获银奖。１９９３年参加第八届全国美展获油画艺术奖。

李延洲
Li Yan-zhou

１９５４年生，毕业于中央美术学院，１９９０年获中央戏剧学院硕士学位。作品《鱼》获第六届全国美展优秀奖，《干草垛》获第二届中国油画年展铜奖，１９９４年在新加坡举办李延洲油画作品展。

李毅松
Li Yi-song

１９６２年生，１９８５年毕业于湖南师范大学美术系油画专业，作品多次入选国内各级美展。

陆成钢
Lu Cheng-gang

１９５８年生，１９８２年毕业于河北师范大学美术系，作品曾参加１９９３年中国油画双年展和第八届全国美展。

吕　鸿
Lu Hong

１９６３年生，１９８９年毕业于中央美术学院油画系。１９９３年作品《幡魂》入选第二届中国油画年展，１９９４年作品《少女与白马在理想的原野上》入选第八届全国美展。

马　俊
Ma Jun

１９６８年生，１９９３年毕业于中央美术学院版画系。

毛岱宗
Mao Dai-zong

１９５５年生，１９８２年毕业于曲阜师范大学，１９９１年结业于中央美院第五届油画研修班。作品《摇篮》入选第六届全国美展，１９９１年作品《暖色田园》组画入选 第一届中国油画年展，１９９４年作品《沂蒙之秋》入选第二届中国油画展，同年作品《山村雪霁》入选 第八届全国美展并获奖。

莫鸿勋
Mo Hong-xun

１９５３年生，１９８２年结业于广州美术学院油画进修班，１９８７年参加首届中国油画展。

宁方倩
Ning Fang-qian

女，１９８８年毕业于中央美术学院壁画系，作品多次参加女画家专题美展。

秦秀杰
Qin Xiu-jie

１９６２年生，１９８７年毕业于东北师范大学美术系，１９９４年作品《八月二十三》入选第八届全国美展。

曲　欣
Qu Xin

１９５９年生，毕业于中央工艺美术学院。１９９３年作品《玻璃门》入选第二届中国油画年展，１９９４年作品《橱窗》入选第八届全国美展。

任　戬
Ren Jian

１９５５年生，１９８４年毕业于鲁迅美术学院，获硕士学位。１９８６年参加第六届国美展，１９８９年参加中国现代艺术展，１９９２年参加广州首届９０年代艺术双年 展，1993年参加香港后'８９中国新艺术展，１９９４年参加意大利现代艺术展。

任建成
Ren Jian-cheng

１９５９年生，毕业于山东艺术学院美术系，１９９４年作品《童年梦系列之一——游行》入选第八届全国美展。

任思鸿
Ren Si-hong

１９６７年生，１９９１年毕业于河北师范学院美术系，１９９１年－１９９３年在中央美术学院油画助教班学习。１９９３年在中央美术学院画廊举办个展，现为职业画家。

申　玲
Shen Ling

女，１９８５年考入中央美术学院油画系四画室。１９８４年参加国际青年美展，１９９１年在中央美术学院画廊举办个展，１９９３年在中国美术馆举办申玲作品展，１９９４年参加第二届中国油画展并获奖，同年参加在香港举办的当代中国油画展，１９９５年参加中华女画家邀请展。

石　冲
Shi Chong

１９６３年生，１９８７年毕业于湖北美术学院油画专业。作品曾获全国美展金奖，银奖，作品奖，美术奖，作品分别在美国、西班牙、瑞典、法国、日本、香港等地展出，其中部分作品被国内外博物馆，美术馆、画廊、私人收藏。

石　磊
Shi Lei

１９６１年生，１９９１年毕业于湖北美术学院，获硕士学位。作品曾参加过第七届、第八届全国美展，第一、第二届中国油画年展，１９９２年参加广州９０年代艺术双年展，并获三等奖，作品曾参加香港国际艺术博览会，台北中国油画精英展。

舒　群
Shu Qun

１９５８年生，１９８４年组织北方艺术群体，任理事长，１９８９年参加北京中国现代艺术展，１９９２年１０月参加广州首届９０年代艺术双年展获学术奖。

苏东平
Su Dong-ping

１９５８年生，１９８３年毕业于沈阳鲁迅美术学院油画系，多次参加全国美展。

孙世伟
Sun Shi-wei

１９６０年生，１９８７年毕业于鲁迅美术学院美术教育系，１９９４年作品《老夫老妻系列之三》参加第二届中国油画展。

谭涤夫
Tan Di-fu

１９４０年生。１９９３年作品《通往远方的路》参加第二届中国油画展并获奖，１９９４年作品《静静的雪山》参加第八届全国美展并获奖。

唐　晖
Tang Hui

１９６８年生，１９９１年毕业于中央美术学院壁画系。

王朝斌
Wang Chao-bin

１９６５年生，１９９１年毕业于湖北美术学院。１９９２年作品参加广州首届90年代艺术双年展，１９９４年参加第二届中国油画展。

王克举
Wang Ke-ju

１９５６年生，１９８３年毕业于山东艺术学院油画系。曾参加过第六届、第七届全国美展和第一届中国油画展。

王利峰
Weng Li-feng

１９６２年生，毕业于中央戏剧学院，多次举办个人画展。

王清丽
Wang Qing-li

１９８６年毕业于湖北美术学院，作品多次参加各种展览。

王卫东
Wang Wei-dong

１９６３年生，１９８９年毕业于山西大学美术系油画专业，１９９４年作品《永恒的记忆》入选第八届全国美展。

| 王沂光 | １９６２年生，１９８０年毕业于山东泰安师专美术系。１９８８年入中央美术学院油画系 |
| Wang Yi-guang | 攻读硕士学位，作品多次参加全国大型美展。 |

| 王玉平 | １９６２年生，１９８９年毕业于中央美院油画系四画室，１９８８年在中国美术馆举办 |
| Wang Yu-ping | 《申玲、王玉平作品展》。１９９１年参加首届中国油画展，１９９３年在中国美术馆举办王 |
| | 玉平作品展，１９９４年参加第二届中国油画展和１９９４年美术批评家年度提名展。 |

| 王云鹏 | １９５５年生，１９９１年参加法国画家伊维尔主持的古典油画材料技法研修班，１９９４ |
| Wang Yun-peng | 年参加第八届全国美展。 |

| 王占武 | １９４９年生，１９８６年毕业于广州美术学院油画系，作品曾多次参加全国性美展。 |
| Wang Zhan-wu | |

| 韦博文 | １９４３年生，曾参加第一、第二届中国油画年展，第二届中国油画展及第八届全国美展等 |
| Wei Bo-wen | 重要全国性大展。 |

| 吴维佳 | １９６０年生，１９８２年毕业于南京艺术学院美术系。１９８９年作品入选第七届全国美 |
| Wu Wei-jia | 展，１９９４年作品《戏剧·人生》参加第二届中国艺术博览会获优秀奖。 |

| 夏俊娜 | １９７１年生，１９９５年毕业于中央美术学院油画系四画室。 |
| Xia Jun-na | |

| 夏小万 | １９５７年生，１９８２年毕业于中央美术学院油画系。１９９２年参加香港后'８９中国 |
| Xia Xiao-wan | 新艺术展，１９９４年参加美术批评家年度提名展。 |

| 谢恒星 | １９５９年生。作品曾入选第六届、第七届、第八届全国美展，１９９２年作品《青海湖》 |
| Xie Heng-xing | 参加中国油画展，１９９２年作品《康巴人家》入选首届广州９０年代艺术双年展。 |

| 谢建德 | １９６２年生，１９８４年毕业于浙江美术学院油画系，作品曾先后入选第六届，第七届、 |
| Xie Jian-de | 第八届全国美展及第一届油画展等全国大展。 |

| 忻东旺 | １９６３年生，１９９３年作品《大河情》入选第二届中国油画年展。 |
| Xin Dong-wang | |

| 徐安民 | １９６０年生，１９９４年作品入选第二届中国油画展，１９９４年参加古巴哈瓦那艺术节。 |
| Xu An-min | |

| 徐　虹 | 女，１９８５年毕业于上海师范大学油画系，１９９２年－１９９３年在中央美术学院美术 |
| Xu Hong | 史系研修班学习。作品曾参加１９８９年中国现代艺术展，１９９３年在悉尼举办的中国新 |
| | 艺术展，１９９５年赴日本、德国的上海现代艺术展。 |

| 许　敏 | 女，１９９３年作品《昨日黄花》入选第二届中国油画年展，１９９４年作品《秋草》参加 |
| Xu Min | 第二届中国油画展，同年入选第八届全国美展并获优秀奖。 |

| 徐晓燕 | 女，１９９３年作品《迷人的原野》参加中国油画双年展并获学术奖，作品《城苑系列》参 |
| Xu Xiao-yan | 加第二届中国油画展。 |

| 杨成国 | １９５６年生，１９８１年毕业于鲁迅美术学院油画系。作品《站在钢琴前的年轻母亲》入 |
| Yang Cheng-guo | 选第七届全国美展并获铜奖，《国家纪念碑－－秦兵马俑》（三联）入选第二届中国油画 |
| | 展，油画《国家纪念碑·汉·西征》入选第八届全国美展。 |

| 燕　杰 | １９４１年生。作品《奶奶和孙子》入选第六届全国美展，《栅栏，牧女和牛犊》参加第二 |
| Yan Jie | 届中国油画展，油画《七月》参加第八届全国美展。 |

阎　萍　女，１９８３年毕业于山东艺术学院，１９９１年获中央美术学院油画研修班优秀证书。作
Yan Ping　品曾获第二届中国油画年展银奖，首届中国油画双年展优秀奖，部分作品被中国及海外美术
馆收藏。

杨国新　１９６５年生，１９９５年毕业于阜阳师范学院美术系。作品曾入选第七届、第八届全国美
Yang Guo-xin　展。

杨国辛　１９５１年生，１９８１年毕业于武汉师范学院美术系。曾参加第七届全国美展，广州首届
Yang Guo-xin　９０年代艺术双年展，１９９３年入选第二届中国油画年展并获铜奖。

姚　永　１９６２年生，１９８１年毕业于山东曲阜师范大学美术系，1991年毕业于中央美术学院油
Yao Yong　画创作研修班。１９９１年参加首届中国油画年展，１９９３年参加第二届中国油画　年
展，１９９４年参加第二届中国油画展。

叶恒贵　１９６２年生，１９８９年毕业于中央美术学院油画系。１９９４年作品《鸟语花香》入选
Ye Heng-gui　第二届中国油画展，１９９５年参加日本中国现代油画展。

于振立　１９４９年生，１９８８年入中央美术学院油画研修班学习。１９８９年作品《吃喜酒的女
Yu Zhen-li　人们》参加八人油画展，１９９４年参加美术批评家年度提名展。

袁文彬　１９６８年生，１９８８年毕业于福建师大美术系，１９９１年参加鲁迅美术学院克劳德·
Yuan Wen-bin　伊维尔材料技法研究班，１９９４年参加中央美院油画系助教进修班。

袁晓舫　１９６１年生，１９８６年毕业于湖北美术学院。作品曾多次入选全国大型美展并获奖。
yuan Xiao-fang

翟　勇　１９６５年生，１９９４年毕业于中央美院第七届油画研修班。作品多次参加国内大型美
Zhai Yong　展，１９８９年作品入选第七届全国美展并获铜奖。

张国龙　１９５７年生，１９８８年毕业于西安美院，获硕士学位。１９９１年赴德国学习现代艺
Zhang Guo-long　术。

张洪波　１９６６年生，１９８９年毕业于中央工艺美术学院。１９９２年参加比利时布鲁塞尔中国
Zhang Hong-bo　艺术家作品展。

张宏伟　１９６７年生，１９８９年毕业于四川三峡学院美术系油画专业。
Zhang Hong-wei

张　晖　１９６８年生，１９９１年毕业于中央美术学院油画系。
Zhang Hui

张　澎　１９５７年生，１９８５年毕业于中央民族学院美术系油画专业，１９９４年结业于中央美
Zhang Peng　术学院壁画系助教进修班。作品曾参加第一届、第二届中国油画年展，１９９４年作品入
选第八届全国美展。

张　昕　１９７０年生，１９９４年毕业于沈阳教育学院美术系。１９８９年作品《旷地上的马》参
Zhang Xin　加青年美术作品展，获佳作奖，１９９３年油画《五个人和一条鱼》参加东北当代油画展，
同年在中央美术学院画廊举办"阶段测验"油画作品展。

张延刚　１９６３年生，１９８９年毕业于中央工艺美术学院装饰艺术系，获硕士学位。１９８９年入
Zhang Yan-gang　选第七届全国美展，１９９３—１９９４年赴法国巴黎国际艺术城进修，１９９４年入选第
八届全国美展。

| | |
|---|---|
| 张永旭<br>Zhang Yong-xu | 1963年生，1989年毕业于中央美术学院油画系四画室，同年留学美国，学习现代艺术。作品多次入选国际性大展。 |
| 张志坚<br>Zhang Zhi-jian | 1963年生，1989年毕业于鲁迅美术学院油画系。作品《阳光》参加1992年中国油画艺术展，亚洲艺术展，作品《梦》参加第二届中国油画年展，并在香港、新加坡巡回展出，一些作品为台湾、香港、新加坡、美国等画廊购藏。 |
| 赵箭飞<br>Zhao Jian-fei | 1959年生，1984年毕业于武汉师范学院艺术系，作品曾多次参加国内外大型展览。 |
| 赵　琨<br>Zhao Kun | 1968年生，1993年毕业于中央美术学院中国画系。 |
| 赵文华<br>Zhao Wen-hua | 1955年生，毕业于内蒙古师范大学美术系。作品曾入选第六届全国美展，中国油画双年展，第二届中国油画年展，第二届中国油画展，亦有多幅作品被国内外美术馆、博物馆收藏。 |
| 赵宪辛<br>Zhao Xian-xin | 1964年生，1994年结业于中央美术学院油画系助教班。1993年参加中国油画双年展，1994年参加第二届中国油画展，1995年参加日本中国现代油画展。 |
| 赵　竹<br>Zhao Zhu | 1964年生，1987年毕业于中央美术学院油画系四画室。1989年作品《长河祭》入选第七届全国美展。 |
| 朱　进<br>Zhu Jin | 1959年生，1980年毕业于安徽巢湖师专美术系。1992年入中央美术学院民间美术系进修。1993年作品《深呼吸》入选中国油画双年展，1994年作品《春困》入选第二届中国油画展，《公主的头纱》入选第八届全国美展。 |
| 朱新建<br>Zhu Xin-jian | 1953年生，1980年毕业于南京艺术学院。曾参加全国美展并获银奖，作品曾被法国国家图书馆，比利时皇家历史博物馆收藏。 |
| 庄　威<br>Zhuang Wei | 1956年生，1989年入中央美院油画系进修。作品多次参加全国性美展。 |

# Biographical notes of Painters in the Third Annual Exhibition of Chinese Oil Painting

### Bai Ming
Born in 1965.Graduated in 1994 from Ceramics Art Department of Central Academy of Arts and Crafts.In 1993 his work was awarded at the Boya Oil Painting Competition,another work was shown at the First Biennial Exhibition of Chinese Oil Painting.In 1994,oil painting was selected at the Memento Exhibition of " Jiangsu Art Monthly".

### Cao Ji-gang
Born in 1955,graduated in 1984 from Central Academy of Fine Arts.His works have been exhibited at the 7th and 8th National Arts Exhibition, '91and '93 Annual Exhibition of Chinese Oil Painting.In 1994 "Small Stream in the Remote Mountain Valley " got the silver award at the Excellent Oil Painting Exhibition.

### Cai Jin
Female,graduated in 1986 from Fine Arts Department of Anhui Normal University, then entered advanced class of oil painting in Central Academy of Fine Arts.In 1987 her work was selected in the First Chinese Oil Painting Exhibition.'94 Exhibition of Chinese Oil Paintings Recommended by Critics.In 1995 she participated in the Chinese Modem Art Exhibition in Sweden.

### Chen Hai-peng
Born in 1963,graduated from Fine Arts Department of shandong Arts College.His works have been selected in several national and regional oil painting exhibitions.

### Chen Lu-shou
Born in 1955,graduated in 1982 from Central Academy of Arts and Crafts.His work "Good Harvest" was exhibited at International Youth Art Exhibition in 1985.In 1992 got the Nomination prize at Guangzhou 90's Biennial Art Exhibition,at the same year participated in Contemporary Art Documentary Exhibition.In 1994 "The wind from Bachu" got the Excellent prize at the 8th National Arts Exhibition.

### Chen Shao-feng
Born in 1961,graduated in 1991 from advanced class of Folk Art Department in Central Academy of Fine Arts.Now is a professional painter in Beijing.

### Chen Shu-xia
Female,graduated in 1987 from Central Academy of Fine Arts.She won the silver award at 91'Annual Exhibition of Chinese Oil Painting.Her works have been exhibited at Chinese Oil Painting Exhibition,93'Annual Exhibition of Chinese Oil Painting.In 1995,held her sole-exhibition both in the gallery of Central Academy of Fine Arts and Shenzhen Art Museum.

### Chen Shu-zhong
Born in 1960,graduated in 1984 from Luxun Academy of Fine Arts.HIs work "Mountain Village"was selected at 91'Annual Exhibition of Chinese Oil Painting and in1993"Market at the wild-grass Shoals"was in the Biennial Exhibition of Chinese Oil painting,"Winter at the wild-grass Shoals"was selected at 93'Annual Exhibiton of Chinese Oil Painting.

### Chen Xi
Female,graduated in 1991 from Oil Painting Department of Central Academy of Fine Arts.In 1993 the work"Popular restaurant"got the Academic prize in the 1st Biennial Exhibition of Chinese Oils.In 1995 two works were exhibited at Contemporary International Art Exhibition in Germany.

### Chen Wei-min
Born in 1959,graduated from Oil Painting Department of Sichuan Academy of Fine Arts.In 1991,his work was selected in the Art Reserch and Documentary Exhibition of Beijing West San Huan Road.In 1993 his work was exhibited at '93 Annual Exhibition of Chinese Oils and got the prize at the Biennial Exhibition of Chinese Oil Painting.In 1994,participated in the Second Chinese Oil Painting Exhibition.

### Deng Jian-jin
Born in 1961,graduated from Sculpture Department of Ceramics Academy in Jiangxi Jingde county.His works have been exhibited at the 7th National Arts Exhibition,the 2nd Contemporary Art Documentary Exhibition of China.The oil painting "To be a happy man" got the Academic prize at the Biennial Exhibition of Chinese Oil Painting.In 1995 visited and held exhibition in U.S.A. as a member of Chinese Oil Painters delegation.

## Ding Fang

Born in 1956,graduated in 1982 from Crafts and Arts Department of Nanjing Academy of Fine Arts,and got the M.D. from the same academy in 1986.Now he is a professional painter. His works have been exhibited and awarded in some major art exhibitions.

## Dong Wen-sheng

Born in 1970,grduated from Industrial Fine Arts Department of Changzhou Technique and Normal College.His works were exhibited at several national art exhibitions.

## Duan Jian-wei

Born in 1961,graduated in 1981 from Fine Arts Department of Henan University.The works were exhibited at '91Annual Exhibition of Chinese Oil painting,the 2nd Chinese Oil painting Exhibition,Contemporary Chinese Oil Painting Exhibition in Hongkong University.In 1991 held United-Exhibition with Duan Zhengqu in the gallery of Central Academy of Fine Arts.

## Duan Jiang-hua

Born in 1963,Graduated from Oil Painting Department of Central Academy of Fine Arts.In 1993 his work "King and Queen No.2" got the Art award at the 2nd Chinese Oil Painting Exhibition.In 1994 "King and Queen with Tie" got the Excellent prize at the 8th National Arts Exhibition.In 1995 visited Japan as a delegate of Chinese Artists' delegation.

## Duan Zheng-qu

Born in 1958,graduated in 1983 from Oil Painting Department  of Guangzhou Academy of Fine Arts.The work "Folk Song" was shown in the 1st Chinese Oil Painting Exhibition in Japan,"Heading West " and "Boatman in the Yellow River" got the Excellent award in '91 Annual Exhibition of Chinese Oil Painting and the 8th National Arts Exhibition.

## Feng Zheng-jie

Born in 1968,graduated in 1995 from Sichuan Academy of Fine Arts and got his M.D.,in 1992 joined Guangzhou the 2nd Documentary Exhibition of Chinese  Contemporary Art, in 1994 his works were exhibited both at the 2nd Chinese Oil Painting Exhibition and Vocational Training Art works Exhibition in Hongkong.

## Fu Jian-feng

Born in 1961,graduated from Oil Painting Department of Sichuan Academy of Fine Arts.His works have been exhibited at Chinese Oil Painting Exhibition,'93 Biennial Exhibition of Chinese Oil Painting, '93 Annual Exhibition of Chinese Oil Painting . Some of his paintings were in the overseas collections.

## Gong Li-long

Born in 1953,graduated in 1982 from Oil Painting Department of Luxun Academy of Fine Arts.In 1980 his work "The Road" got the 2nd prize at the 2nd Youth Art Exhibition.  "Clown" and "Fasion" were included in '91and '93Annual Exhibition of Chinese Oil Painting, "Play Billiard Ball" was awarded at the 8th National Arts Exhibition. In 1994 the work was shown at '94 Exhibition of Chinese Oil Paintings Recommended by Critics.

## Gu Li-ming

Born in 1963,graduated from Fine Arts Department of Shandong Qufu Normal University.In 1987 entered advanced class of oil painting in Central Academy of Fine Arts,at the same year the work was shown in the Chinese Modern Art Exhibition,in 1993 won the Academic award at the Biennial Exhibition of Chinese Oils,and Participated in the '93 Annual Exhibition of Chinese Oils,in 1994 got award at the 8th National Arts Exhibition.

## Guo Jin

Bron in 1964,graduated from Oil Painting Department of Sichuan Academy of Fine Arts.In 1992 took part in the 1st Guangzhou Biennual Arts Exhibition.In 1994 his work was exhibited at '94 Strange Scene Exhibition.

## Guo Run-Wen

Born in 1955,graduated  in 1982 from Stage Art Department of Shanghai Drama College. In 1988 completed study in advanced class of oil painting in Central Academy of Fine Arts.His work  "Trace" won the Academic award at the Biennial Exhibition of Chinese Oil Painting, "Eternal memory" was given Art prize at the 2nd Chinese Oil Painting Exhibition,In 1995 visited and held exhibition in U.S.A as a member of Chinese oil painters' delegation.

## Guo Zheng-shan

Born in 1954,Participated in the '91 Annual Exhibition of Chinese Oil  Painting.In 1992 his work was given Nomination prize at

Guangzhou 90's Art Exhibition of Chinese Oil Painting.In 1994 won the Academic prize at the Biennial Exhibition of Chinese Oils.

## Han Da-wei

Born in 1961,graduated from Luxun Academy of Fine Arts.He got the Nomination prize at Guangzhou 90's Biennial Art Exhibition.His works have been exhibited at the 2nd Chinese Oil Painting Exhibition and the 8th National Arts Exhibition.

## Han Dong

Born in 1958,graduated from Nanjing Arts Academy.In 1992 his work "Room Feature" was awarded the 3nd prize at Guangzhou 90's Biennial Exhibition of Chinese Oil Painting.

## Han Xiong

Born in 1965,graduated from Hubei Academy of Fine Arts.His work "Group-photo 1994" was shown at the 8th National Arts Exhibition.

## He Sen

Born in 1968,graduated in 1989 from Sichuan  Academy of Fine Arts. His work was selected in the '91 Annual Exhibition of Chinese Oil Painting,another one got the Nomination award at Guang zhou 90's Biennial Art Exhibition.In 1993 he joined Post '89 Chinese New Art Exhibition and Biennial Exhibition of Chinese Oils, '93 Annual Exhibition of Chinese Oil painting.

## Hong  Ling

Born in 1955,graduated in 1979 from Fine Arts Department of Beijing Normal College and in 1987 completed study in advanced class of oil painting in Central Academy of Fine Arts.In 1991 got the Excellent prize at '91 Annual Exhibition of Chinese Oil Painting,in 1993 "Spirit of landseape" was given Bronze award at  '93 Annual Exhibition of Chinese Oil Painting.In 1994 his work was selected in the 2nd Chinese Oil Painting Exhibition.

## Hu Chao-yang

Born in 1959,graduated in 1983 from Fine Arts Department of Hubei Academy of Fine Arts.His works have been exhibited at numerous major exhibitions.

## Hu Jun-rong

Born in 1969,graduated in 1992 from Traditional Chinese Painting Department of Zhejiang Academy of Fine Arts.His works have been exhibited in numerous major art exhibitions.

## Jia Juan-li

Female,graduated in 1986 from Oil Painting Department of Sichuan Academy of Fine Arts and received M.F.A. from Oil Painting Department of Central Academy of Fine Arts in 1991.The work "Qiu Jin" was included in Shanghai 1st Chinese Oils Exhibition, "Chess Player" was in  the 7th National Arts Exhibition.Held her first sole-exhibition in the gallery of Central Academy of Fine Arts.

## Jiang Hai

Born in 1961,graduated in 1986 from Oil Painting Department of Tianjin Academy of Fine Arts.His work was included in the Chinese Modern Art Exhibition in 1989,got the Nomination award at Guangzhou 90's Biennial Arts Exhibition in 1992 and Biennial Exhibition of Chinese Oils.He also joined the 2nd Chinese Oils Exhibition in 1993 and '93 Annual Exhibition of Chinese Oil Painting.

## Jing Shi-jian

Born in 1960.His works have been exhibited at the 6th,7th National Arts Exhibition.

## Jin Tian

Born in 1960,graduated from Fine Arts Department of Nanjing Arts Academy.His works have been selected in several major national art exhibitions.

## Kang Xiao-yu

Born in 1956,graduated in 1982 from Oil Painting Department of Xian Academy of Fine Arts.In 1993 the work "The Standing Nude" was selected in the Biennial Exhibition of Chinese Oil Painting in Beijing.His works were exhibited in several major overseas and national exhibitions.

## Lei Shuang

Female,graduated from advanced class of Oil Painting Department in Central Academy of Fine Arts.Her works have been exhibited at '91 ,'93 Annual Exhibition of  Chinese Oil Painting, the  2nd Chinese Oil Painting Exhibition in 1994 and the 8th National

Arts Exhibition.

## Leng Jun

Born in 1962,graduated in 1984 from Arts Department of Wuhan Normal Umiversity. The work "The Story of Barn Lantern" was given the Bronze award at the National Arts Exhibition,in 1992 another work got the Excellent prize at Guangzhou 90's Biennial Art Exhibition.His works have been exhibited in some national art exhibitions and got some awards.

## Liang Biao

Born in 1963,graduated in 1989 from Arts Academy of Ha Erbin Normal University.In 1994 entered advanced class of oil painting in Central Academy of Fine Arts.

## Liao Bang-ming

Born in 1967,graduated in 1992 from Woodcut Department of Sichuan Academy of Fine Arts.Now is a professional painter.Some of his works are in the overseas collections.

## Li Bang-yao

Born in 1954,graduated in 1978 from Fine Arts Department of Hubei Arts College.In 1989 his work "Wild Grass" was shown at the Chinese Modern Art Exhibition and in 1992 he got the excellent award at Guangzhou 90's Biennial Art Exhibition.

## Lin Jing-jing

Female,graduated in 1992 from Oil Painting Department of Fujian Normal University. From 1994 to 1995 kept her study in advanced class in Central Academy of Fine Arts.

## Liu Gang

Born in 1965,graduated from Oil Painting Department of Central Academy of Fine Arts.In 1989 his work "The Trace" was shown a the 7th National Arts Exhibition,in 199 1"Flowing at the One Direction" was in France Salon Exhibition."Two Different Direction" was selected in '91 Annual Exhibition of Chinese Oil Painting,and in 1993 " Metal Series" got the Gold award at the Biennial Exhibition of Chinese Oil Painting.

## Liu Da-ming

Born in 1961,graduated in 1986 from Fine Arts Department of Jilin Arts Academy.In 1989 his work "Terminal" got the Bronze award at the 7th National Arts Exhibition,in 1993 "The Wall-Feature in the Court of Qing Dynasty" was shown at the Biennial Exhibition of Chinese Oils,in 1994"Feature in the Court of Qing Dynasty-Cage Bird" was in the 2nd Chinese Oils Exhibition.

## Liu Guo-xin

Born in 1966,some of his works are in the overseas collections.

## Liu Jian

Born in 1958,graduated from Fine Arts Department of Beijing Normal Academy,and completed class for assistant teachers in Hubei Academy of Fine Arts.In 1994 the work "Sunflower Land" was selected in the 2nd Chinese Oil Painting Exhibition."The Mask" was in the 8th National Arts Exhibition.

## Liu Li-ping

Female,graduated from Woodcut Department of Central Academy of Fine Arts.In1993 got the Academic award at the 1st Biennial Exhibition of Chinese Oil Painting.Participated in several special subject exhibitions of female artist.Her work is collected by Ludwig Museum of Germany.

## Liu Ming

Born in 1957,In 1989 got the Silver award at the 7th National Arts Exhibition,in 1991 got the Bronze award at 91' Annual Exhibition of Chinese Oil Painting,in 1993 got the Academic prize at the Biennial Exhibition of Chinese Oil Painting,in 1994 got the Art award at the 8th National Arts Exhibition.

## Li Yan-zhou

Born in 1954,graduated from Central Academy of Fine Arts and got the M.D.in 1990 from Central Academy of Drama.The work "Fish" got the Excellent award at the 6th National Arts Exhibition, "Haystack" got the Bronze award in the '93 Annual Exhibition of Chinese Oil Painting.In 1994 held Li Yanzhou Oil Painting Exhibition in Singapore.

## Li Yi-song

Born in 1962,graduated in 1985 from Fine Arts Department of Hunan Normal University.His works have been exhibited in several

national art exhibitions.

## Lu Cheng-gang
Born in 1958,graduated in 1982 from Arts Department of Hebei Normal University.His works were exhibited at '93 Biennial Exhibition of Chinese Oil Painting and the 8th National Arts Exhibition and the other major exhibitions.

## Lu Hong
Born in 1963,graduated from Oil Painting Department of Central Academy of Fine Arts.In 1993 the work "The Spirit of Streamers" was in the '93 Annual Exhibition of Chinese Oil Painting,in 1994 "The Maid with White Horse in the Beautiful Expanse Grass" in the 8th National Arts Exhibition.

## Ma Jun
Born in 1968,graduated in 1993 from Woodcut Department of Central Academy of Fine Arts.

## Mao Dai-zong
Born in 1955,graduated in 1982 from Qufu Normal University,and completed study in advanced class of oil painting in Central Academy of Fine Arts.The work"Cradle"was in the 6th National Arts Exhibition,in 1991 "Warm Land" in '91 Annual Exhibition of Chinese Oil Painting,in 1993 "Autumn in the Yimeng District" in the 2nd Chinese Oil Painting Exhibition.

## Mo Hong-xun
Born in 1953,completed study in 1982 from advanced class of oil painting in Guangzhou Academy of Fine Arts.In 1987 the work was shown in the 1st Chinese Oil Painting Exhibition.

## Ning Fang-qian
Female,graduated from Mural Painting Department of Central Academy of Arts.Her works were included in some special subject exhibitionsof female painter

## Qin Xiu-jie
Born in 1962,graduated from Fine Arts Department of Dongbei Normal University.In 1994 the work "23nd,August" was selected in the 8th National Arts Exhibition.

## Qu Xin
Born in 1959,graduated from Central Academy of Arts and Crafts.In 1993 the work "Glass Door" was shown at '93 Annual Exhibition of Chinese Oil Painting and in 1994 "Shopwindow" was selected in the 8th National Arts Exhibition.

## Ren Jian
Born in 1955,got the M.D. in 1984 from Luxun.Academy of Fine Arts.His works were exhibited in the 6th National Arts Exhibition in 1986,Chinese Contemporary Art Exhibition in 1989, Guangzhou 90's Biennial Art Exhibition in 1992,Post '89 Chinese Art Exhibition in Hongkong in 1993,Modern Art Exhibition in Italy in 1994.

## Ren Jian-cheng
Born in 1959,graduated from Fine Arts Department of Shandong Arts College.In 1994 the work "The Child's Dream No.1--Parade" was shown at the 8th National Arts Exhibition.

## Ren Si-hong
Born in 1967,from 1987 to 1991 studied in Fine Arts Department of Hebei Normal College,1991 to 1993 studied in the class of oil painting from assistant teachers in Central Academy of Fine Arts.Held his sole-exhibition in the gallery of Central Academy of Fine Arts and now is a professional painter.

## Shen Ling
Female,entered the 4th studio of Oil Painting Department of Central Academy of Fine Arts.Held the sole-exhibition in the gallery of the aboved Academy in 1991,in 1993held Sheng Ling Art Work Exhibition in the China.National Arts Museum.In 1994 got the award in the 2nd chinese Oil Painting Exhibition and was selected in the Contemporary Chinese Oils Exhibition.

## Shi Chong
Born in 1963,graduated in 1987 from Oil Painting Department of Hubei Academy of Fine Arts.The works were given Gold,Silver,Bronze,Artwork award and shown in the U.S.A.,Spanish,Sweden,France,Japan,Hongkong and so on.Some of them are in the collections by overseas museums and galleries.

## Shi Lei

Born in 1961,graduated in 1991 as a post-graduate student of Hubei Academy of Fine Arts and got the M.D.,The works were shown in the 7th,8th National Arts Exhibition,'91 ,'93 Annual Exhibition of Chinese Oil Painting,Guangzhou 90's Biennial Art Exhibition and got the award,Hongkong International Art Expo.Chinese Excellent Oil Painting Exhibition in Taipei.

## Shu Qun

Born in 1958,in 1984 organized the North Art Group and to be a councellor.In 1989 participated in the Chinese Modern Art Exhibition in Beijing and in 1992 got the Academic award at Guangzhou 90's Biennial Art Exhibition.

## Su Dong-ping

Born in 1958,graduated from Oil Painting Department of Luxun Academy of Fine Arts in Shenyang.The works have been exhibited in some national art exhibitions.

## Sun Shi-wei

Born in 1960,graduated in 1987 from Education Department of Luxun Academy of Fine Arts  A.In 1994 the work "The Old Couple Series No.3" was in the 2nd Chinese Oil PaintingExhibition.

## Tan Di-fu

Born in 1940.In 1993 the work "The Way to the Distant Place" got the award at the 2nd Chinese Oil Painting Exhibition,in 1994 "Silent Snow Mountain" got the award at the 8th  National Arts Exhibition.

## Tang Hui

Born in 1968,graduated in 1991 from Mural Painting Department of Central Academy of Fine Arts

## Wang Chao-bin

Born in 1965,graduated in 1991 from Hubei Academy of Fine Arts.The work was selected in Guangzhou 90's Biennial Art Exhibition in 1992,the 2nd Chinese Oil Painting Exhibition in 1994.

## Wang Ke-ju

Born in 1956,graduated in 1983 from Oil Painting Department of Shandong Arts College.The works are in the 6th,7th National Arts Exhibition and the 1st Chinese Oil Painting Exhibition.

## Wang Li-feng

Born in 1962,graduated from Central Academy of Drama.Have held several sole-exhibitions

## Wang Qing-li

Female,graduated from Hubei Academy of Fine Arts.The works have been exhibited in some major art exhibitions.

## Wang Wei-dong

Born in 1961,graduated in 1989 from Oil Painting Department of Shanxi University.In 1994 the work "Eternal Memory" was selected in the 8th National Arts Exhibition.

## Wang Yi-guang

Born in 1962,graduated in 1980 from Fine Arts Department of Taian  Vocational school in Shandong province.In 1988 entered Central Academy of Fine Arts to be a graduate student.The works have been exhibited in some major national art exhibitions.

## Wang Yu-ping

In 1985 entered the 4th studio of Oil Painting Department of Central Academy of Fine Arts.In 1988 held Shen Ling and Wang Yuping Artwork Exhibition in the China National Arts Museum.His works were shown at the 1st,2nd Chinese Oil Painting Exhibition in 1991 and 1994.He was invited to '94  Exhibition of Chinese Oil Paintings Recommended by Critics.

## Wang Yun-peng

Born in 1955.In 1991 entered advanced class of material and skill of classical oil painting taught by French Painter Iver.In 1994 the work was selected in the 8th National Arts Exhibition.

## Wang Zhan-wu

Born in 1949,graduated in 1986 from Oil Painting Department of Guangzhou Academy of Fine Arts. The works have been exhibited in several national art exhibitions.

## Wei Bo-wen

Born in 1943,the works have been exhibited in the following exhibitions: '91 and '93 Annual Exhibition of Chinese Oil Painting, the 2nd Chinese Oil Painting Exhibition,the 8th National Arts Exhibition and other national art exhibitions.

## Wu Wei-jia

Born in 1960,graduated in 1982 from Fine Arts Department of Nanjing Arts Academy.In 1989 the work was shown in the 7th National Arts Exhibition and in 1994 "Drama Life" was given the Excellent award in the 2nd Chinese Art Expo.

## Xia Jun-na

Female,graduated in 1995 from Oil Painting Department of Central Academy of Fine Arts.

## Xia Xiao-wan

Born in 1959,graduated in 1982 from Oil Painting Department of Central Academy of Fine Arts.The works were exhibited in Post '89 Modern Art Exhibition,94' Exhibition of Chinese Oil Paintings Recommended by Critics.

## Xie Heng-xing

Born in 1959,The work was shown in the 6th,7th,8th National Arts Exhibition.In 1992 "Qinghai Lake" was in the 2nd Chinese Oil Painting Exhibition, "Kangba Family" in Guangzhou 90's Biennial Art Exhibition in 1992.From 1992 to 1993 held the 1st and 2nd sole-exhibition in Guangzhou.In 1994 held a sole-exhibition in Dancing Inka in the U.S.A.

## Xie Jian-de

Born in 1962,graduated in 1984 from Oil Painting Department of Zhejiang Academy of Fine Arts.The works have been exhibited in the 6th,7th,8th National Arts Exhibitions and the 1st Chinese Oil Painting Exhibition and other major exhibitions.

## Xin Dong-wang

Born in 1963,the oil painting "Feelings for the River" was selected in '93 Annual Exhibition of Chinese Oil Painting.

## Xu An-min

Born in 1960.In 1992 participated in Post '89 Chinese New Art Exhibition.In 1994 the work was selected in the 2nd Chinese Oil Painting Exhibition and in the Hawana Festival in Cuba.

## Xu Hong

Female,graduated in 1985 from Oil Painting Department of Shanghai.Normal University.From 1992 to 1993 studied in advanced class of Art History Department in Central Academy of Fine Arts.The works have been exhibited in the following exhibitions:Chinese Modern Art Exhibition in 1989,Chinese New Art Exhibition in Sndney,Austrilia in 1993,Shanghai Modern Art Exhibition in Japan,Germany in 1995.

## Xu Ming

Female. In 1993 the work "Yesterday Yellow Flower" was selected in '93 Annual Exhibition of Chinese Oil Painting, in 1994 "Autumn Grass" in the 2nd Chinese Oil Painting Exhibition and got the Excellent prize in the 8th National Arts Exhibition.

## Xu Xiao-yan

Female. In 1993 the work "The Charming Grass-land" got the Academic award in the Biennial Exhibition of Chinese Oil Painting, "Cities Series" was shown in '93 Annual Exhibition of Chinese Oil Painting.

## Yang Cheng-guo

Born in 1956, graduated in 1981 from Oil Painting Department of Luxun Academy of Fine Arts. The work "The Younger Mother Stands Before the Piano" got Bronze award in the 7th National Arts Exhibition, "First Visit at the Parnirs" was included in '93 Annual Exhibition of Chinese Oil Painting, "Natonal Monument: Terra-Cotta Warriors" was shown in the 2nd Chinese Oil Painting Exhibition, "National Monument: Han Dynasty Expetiion to West" was in the 8th National Arts Exhibition.

## Yan Jie

Born in 1941.The work "Grandmother and Grandson" was exhibited at the 6th National Arts Exhibition, "Frame,Herdsgirl and Cow" was in the 2nd Chinese Oil Painting Exhibition. "Jnly" in the 8th National Arts Exhibition.

## Yan Ping

Female,graduated in 1983 from Shandong Arts College.In 1991 entered advanced class of oil painting in Central Academy of

Fine Arts and got excellent certification.The work is given Silver award in '93 Annual Exhibition of Chinese Oil Painting,the Excellent award in '93 Biennial Exhibition of Chinese Oils and the 3th National Arts Exhibition.Some of her works are in the collections by Chinese Art Museum and Foreign Art Museum.

## Yang Guo-xin

Born in 1956,graduated in 1995 from Fine Arts Department of Fuyang Normal University.The works were exhibited in the 7th,8th National Arts Exhibitions.

## Yang Guo-xin

Born in 1951,graduated in 1981 from Fine Arts Department of Wuhan Normal University.The works have been exhibited in the 7th National Arts Exhibition,the 1st Guangzhou Biennial Art Exhibition,the 2nd Chinese Oil Painting Exhibition,in 1993 the work got Bronze award in '93 Annual Exhibition of Chinese Oil Painting.

## Yao Yong

Born in 1962,graduated in 1982 from Fine Arts Department of Qufu University in Shandong province.In 1991 entered advanced class of oil painting in Central Academy of Fine Arts.His works were exhibited in '91 and '93 Annual Exhibition of Chinese Oil Painting the 2nd Chinese Oil Painting Exhibition in 1994.

## Ye Heng-gui

Born in 1962,graduated in 1989 from Fine Arts Department of Huazhong Normal University.The works are included in national and international major exhibitions.

## Yu Zhen-li

Born in 1949.In 1989 the work "Women in the Wedding Day" was shown in the Exhibition by 8 Persons.In 1994 was selected in '94 Exhibition of Chinese Oil Paintings Recommended by Critics.

## Yuan Wen-bin

Born in 1968,graduated in 1988 from Fine Arts Department of Fujian Normal University.In 1991 entered class of material skill taught by Klaud Iver in Luxun Academy of Fine Arts.From 1994 to 1996 studied in advanced class of oil painting in Central Academy of Fine Arts.

## Yuan Xiao-fang

Born in 1961,graduated in 1986 from Hubei Academy of Fine Arts.The works were selected in some national art exhibitions.

## Zhai Yong

Born in 1965,graduated in 1994 from advanced class in Central Academy of Fine Arts.The works have been exhibited in some national exhibitions.In 1989 got Bronze award in the 7th National Arts Exhibition.

## Zhang Guo-long

Born in 1957,got M.D. in 1988 from Xian Academy of Fine Arts.In 1991 go abroad  to study modern art in Germany.

## Zhang Hong-bo

Born in 1966,graduated in 1989 from Central Academy of Arts and Crafts.In 1991 moved to Art village of Royal Palace.In 1992 the work was shown in the Chinese Artists' Work Exhibition in Belgium.In 1993 Participated in the 1st Chinese Professional. Painters, Exhibition and in 1995 joined the Works Exhibition of Art Village of Royal  Palace in Nanjing Arts Academy

## Zhang Hong-wei

Born in 1967,graduated in 1989 from Fine Arts Department of Sichuan Sanxia College.

## Zhang Hui

Born in 1968,graduated in Mural Painting Department of Central Academy of Fine.

## Zhang Peng

Born in 1957,graduated from Oil Painting Department of Central Nationality Academy. In 1994 Completed higher-training class of Mural Painting Department in Central Academy of  Fine Arts.The works are included in 91',93' Annual Exhibition of Arts Oil Painting, the 8th National Art Exhibition in 1994.

## Zhang xin

Born in 1970,graduated in 1994 from Fine Arts Department of Shenyang Education College. In 1989 the work "horse on the Wild Land" was given the Excellent award in shenyang Youth Art Exhibition.In 1993 "Five People and One Fish" was in the North-East Contemporary Oil Painting Exhibition.In 1994 held Phase-Test Oil Painting Exhibition in the gallery of Central Academy of Fine Arts.In 1995 he was honoured the title of one of 10 "Out-standing Young Artist of Shenyang".

## Zhang Yan-gang
Born in 1963,got M.D. of Decorative Art Department of Central Academy of Crafts 1989.In 1989 the work was shown in the 7th National Arts Exhibition.From 1993 to 1994 studied in International Art City of France.In 1994 the work was exhibited in the 8th National Arts Exhibition.

## Zhang Yong-xu
Born in 1963,graduated in 1989 from Oil Painting Department of Central Academy of Arts.The works are in some international art exhibitions.

## Zhang Zhi-jian
Born in 1963,graduated in 1989 from Oil Painting Department of Luxun Academy of Fine Arts.The work "Sunlight" was shown in the Chinese Oil Painting Exhibition in 1992 and Asia Art Exhibition, "Dream" was selected in '93 Annual Exhibition of Chinese Oil Painting and was exhibited in Hongkong and Singapore.Some of his works were in the collections by Taiwan,Hongkong,Singapore and U.S.A..

## Zhao Jian-fei
Born in 1959,graduated in Fine Department of Wuhan Nornal University.The works have been shown in some major exhibitions.

## Zhao Kun
Born in 1968,graduated in 1993 from Traditional Chinese Painting Department of Central Academy of Fine Arts.

## Zhao Wen-hua
Born in 1955,graduated from Fine Arts Department of Nei Menggu Normal University.The works were shown in the 6th National Arts Exhibition,'93 Biennial Exhibition of Chinese Oil Painting,'93 Annual Exhibition of Chinese Oil Painting, the 2nd Chinese Oil Painting Exhibition.Some of them are in the collections by overseas museums and galleries.

## Zhao Xian-xin
Born in 1964,completed advanced class of oil painting in Central Academy of Fine Arts.The works have been shown in the Biennial of Chinese Oil Painting in 1993, the 2nd Chinese Oil Painting Exhibition in 1994, Chinese Modern Oil Painting Exhibition in 1995.

## Zhao Zhu
Graduated in 1987 from Oil Painting Department of Central Academy of FineArts. In 1989 the work "Sacrifice for the Long River" was shown in the 7th National Arts Exhibition.

## Zhu Jin
Born in 1959, graduated in 1980 from Fine Arts Department of Chaohu Vocational School in Anhui provinece. In 1992 entered advanced class in Folk Arts Department of Central Academy of Fine Arte. In1993 the work "Deep Breath" was shown in the Biennial Exhibition of Chinese Oil Painting, "Spring Sleepy" in the 2nd Chinese Oil Painting Exhibition, "Gauze Kerchief of Pricess" in the 8th National Arts Exhibition.

## Zhu Jian-xin
Born in 1953,graduated in 1980 from Nanjing Arts College.Has got Silver award in the National Arts Exhibition.The works are in the collections by France National Liberary,Belgium History Museum.

## Zhuang Wei
Born in 1956,entered Oil Painting Department of Central Academy of Fine Arts in 1989.The works were exhibited in some national art exhibitions.

# 入选作者名单索引

## INDEX

| | | |
|---|---|---|
| 石　冲 | 50 | Shi Chong |
| 石　磊 | 156 | Shi Lei |
| 舒　群 | 126 | Shu Qun |
| 苏东平 | 60 | Su Dong-ping |
| 孙世伟 | 90 | Sun Shi-wei |
| 谭涤夫 | 89 | Tan Di-fu |
| 唐　晖 | 69 | Tang Hui |
| 王朝斌 | 122 | Wang Chao-bin |
| 王克举 | 95 | Wang Ke-ju |
| 王利丰 | 116 | Wang Li-feng |
| 王清丽 | 83 | Wang Qing-li |
| 王卫东 | 144 | Wang Wei-dong |
| 王沂光 | 117 | Wang Yi-guang |
| 王玉平 | 146 | Wang Yu-ping |
| 王云鹏 | 141 | Wang Yun-peng |
| 王占武 | 98 | Wang Zhan-wu |
| 韦博文 | 125 | Wei Bo-wen |
| 吴维佳 | 70 | Wu Wei-jia |
| 夏俊娜 | 52 | Xia Jun-na |
| 夏小万 | 147 | Xia Xiao-wan |
| 谢恒星 | 160 | Xie Heng-xing |
| 谢建德 | 92 | Xie Jian-de |
| 忻东旺 | 53 | Xin Dong-wang |
| 徐安民 | 82 | Xu An-min |
| 徐　虹 | 68 | Xu Hong |
| 许　敏 | 100 | Xu Min |
| 徐晓燕 | 49 | Xu Xiao-yan |
| 杨成国 | 48 | Yang Cheng-guo |
| 杨国新 | 59 | Yang Guo-xin |
| 杨国辛 | 67 | Yang Guo-xin |
| 燕　杰 | 94 | Yan Jie |
| 阎　萍 | 54 | Yan Ping |
| 姚　永 | 87 | Yao Yong |
| 叶恒贵 | 101 | Ye Heng-gui |
| 袁文彬 | 142 | Yuan Wen-bin |
| 袁晓舫 | 80 | Yuan Xiao-fang |
| 于振立 | 72 | Yu Zhen-li |
| 翟　勇 | 120 | Zhai Yong |
| 张国龙 | 74 | Zhang Guo-long |
| 张洪波 | 157 | Zhang Hong-bo |
| 张宏伟 | 97 | Zhang Hong-wei |
| 张　晖 | 123 | Zhang Hui |
| 张　澎 | 121 | Zhang Peng |
| 张　昕 | 140 | Zhang Xin |
| 张延刚 | 134 | Zhang Yan-gang |
| 张永旭 | 128 | Zhang Yong-xu |
| 张志坚 | 149 | Zhang Zhi-jian |
| 赵箭飞 | 103 | Zhao Jian-fei |
| 赵　琨 | 99 | Zhao Kun |
| 赵文华 | 102 | Zhao Wen-hua |
| 赵宪辛 | 96 | Zhao Xian-xin |
| 赵　竹 | 85 | Zhao Zhu |
| 朱　进 | 139 | Zhu Jin |
| 朱新建 | 106 | Zhu Xin-jian |
| 庄　威 | 91 | Zhuang Wei |

书　　名：第三届中国油画年展作品集
主　　办：北京东方艺术厅
总 监 制：杜文彬
主　　编：刘骁纯　何　冰
出版策划：杨小彦
责任编辑：赵克标
编　　辑：柴　宁
美术编辑：傅　沙
英文编辑：唐　煜
英文翻译：唐　煜　潘知新
编　　务：李绍华　江　南　李桂娟　曾　松　廖锦麟　徐　叶　冯瑞贤
摄　　影：傅春芳
设　　计：傅　沙　陈雄伟
印刷监制：傅　沙　林伟梁
出　　版：岭南美术出版社
制　　作：广州智圣广告有限公司
印　　刷：广州新辉彩印有限公司
出版日期：1995年12月第一版第一次印刷
书　　号：ISBN 7-5362-1343-3/J·1215
定　　价：￥238.00

Name of Catalogue: Selected Works of the Third Annual Exhibition of Chinese Oil Painting
Presented by: Beijing Oriental Art Galley
Chief Diretor: Du Wen-hin
Chief Editors: Liu Xiao-chun He Bing
Publisher Planner: Yang Xiao-yan
Responsible Editor: Zhao Ke-biao
Editor: Chai Ning
Editor of Fine Arts: Fu Sha
English Editor: Tang Yu
Translaters: Tang Yu Pan Zhi-xin
officers of Editor: Li Shao-hua Jiang Nang Li Gui-juan Zen Song Liao Jin-lin Xu Ye Feng Rui-xian
Photographer: Fu Chun-fang
Design: Fu Sha Chen Xiong-wei
Printing Director: Fu Sha Lin Wei-liang
Publisher: Lingnan Art Publishing House
Production: Guangzhou Jack Saint Advertising Co.Ltd
Printer: GUANGZHOU SUNFLOWER PRINTING CO.,LTD
Date of Publish: 1995.12.
Isbn: ISBN 7-5362-1343-3/J·1215
Price: ￥238.00